DRAWING SECRETS REVEALED
BASICS

NORTH LIGHT BOOKS
CINCINNATI, OHIO
www.artistsnetwork.com

CONTENTS

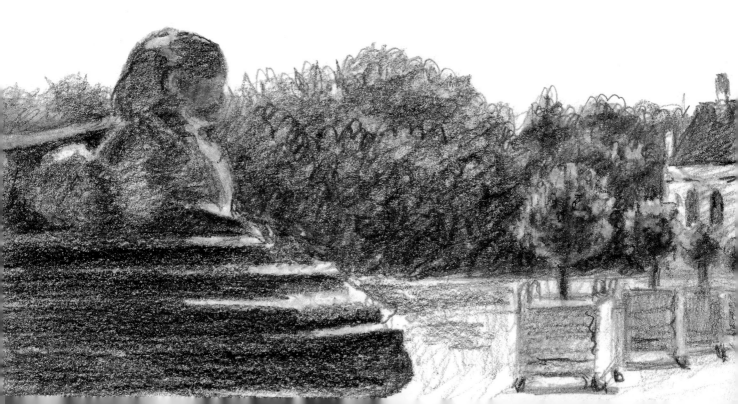

Chenonceau Entrance
Graphite and charcoal on paper
8½" × 14" (22cm × 28cm)

INTRODUCTION

It's a common misconception that you have to be born with artistic talent or that only creative people can draw or paint. But in fact, drawing is a discipline just like any other, requiring learning skills and practicing techniques. And your keen desire to draw gives you the aptitude you need to study those skills and diligently practice the techniques I'm going to teach you. When you've practiced them consistently, you'll really start to feel pride in your ability to draw. Suddenly people will say, "I didn't know you were so talented!"

To tell you the truth, I don't think anyone can be truly finished with learning to draw—most of the best artists say they are still learning, and every effort, whether it's great or not so good, is a learning process for them. That's how we improve. But that feeling of accomplishment that comes over you when what you draw matches what you see—that is what you can begin to achieve with this book.

With this book, I hope to make you aware of what you can accomplish as an artist in the realm of graphite and charcoal. And if at some point you are interested in moving on to painting with color mediums, you'll notice how your paintings improve because of your solid drawing skills. I have noticed in many painting workshops that students struggle because they are essentially trying to learn two challenging disciplines—drawing and painting—at the same time and they feel like failures because they can't get the desired results. So they assume they aren't good artists when really, they've just put the cart before the horse. Learn your drawing skills first, then develop your painting skills.

Some students will nullify good drawing skills and say they are painting impressionistically, but the Impressionists were excellent draftsmen; they had extensive training in drawing faces, figures and landscapes. It was their paint strokes that were impressionistic, but those artists weren't sloppy when constructing their compositions. Monet's figures weren't disjointed, Degas's ballerinas and horses still obeyed the laws of perspective, and Manet and Renoir could draft a well-drawn face.

Many drawing books that claim to be aimed at beginners incorporate way too much information with lots of bells and whistles and a plethora of advanced techniques and materials. The developing artists are left overwhelmed and don't know where to start. I'm not going to inundate you with every technique, material, color medium and approach because, let's face it, art is a vast continent and you can exhaust yourself trying to cover all the terrain. What I've tried to do with this book is to hone that artistic topography into an exciting but manageable vista that will allow you to master the foundational concepts you need to embark on any artistic genre or medium that snares your interest.

More than just teaching you how to draw any one particular thing, the purpose of this book is to teach you how to draw anything you see. *Anything.* That requires a systematic, methodical approach to lay a solid foundation with each concept building on the previous. If you take the time to learn and practice the concepts in this book diligently, you'll find yourself able to draw pretty much anything you see around you, no matter how complicated, because you will know how to strip a composition down to its basics and then build on that.

Happy Drawing!
Sarah Parks

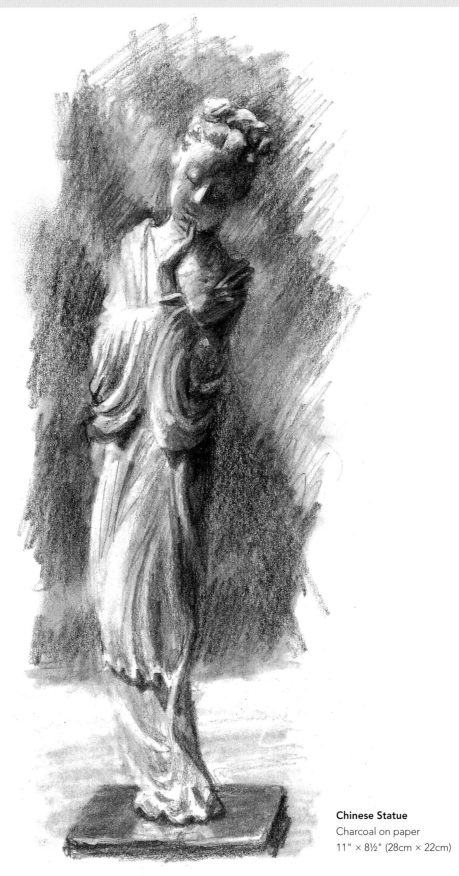

Chinese Statue
Charcoal on paper
11" × 8½" (28cm × 22cm)

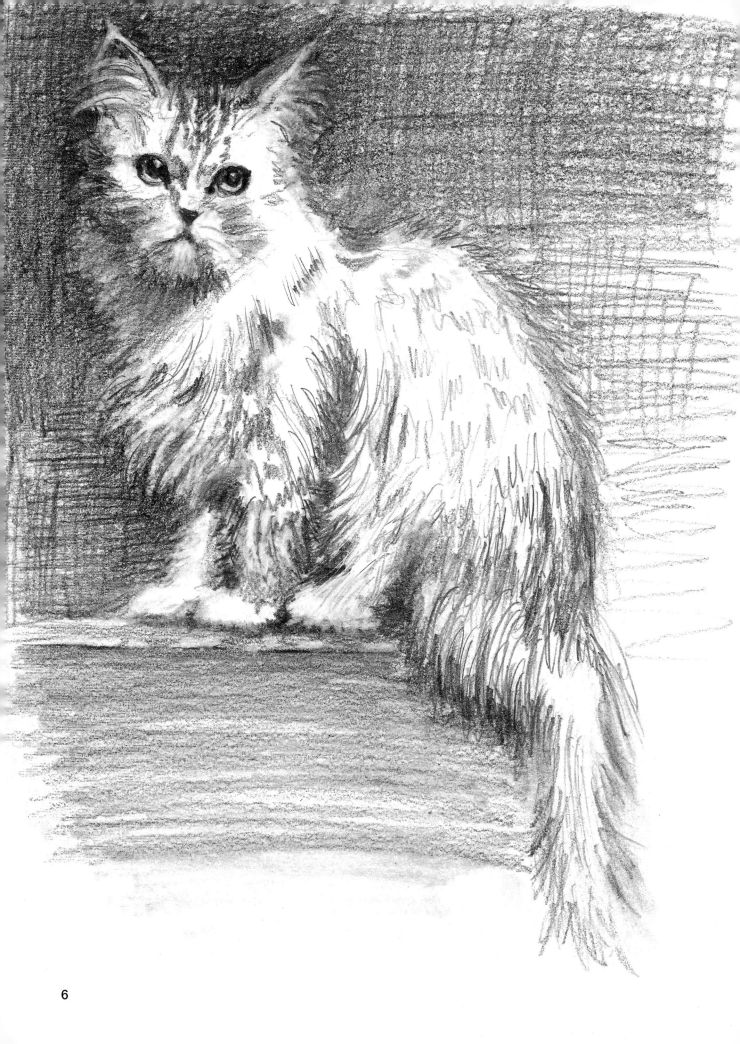

1 GETTING STARTED

If you're like most new artists, you see a beautiful finished sketch or drawing and you think, *I want to do that*! But you may have no idea just how that was achieved. A host of questions need to be answered to be able to create something like that yourself, but how do you know what questions to ask? And where do you go for the answers? Few of us want to search a hundred different sources just to get a foundation of understanding.

And what if you're a more experienced artist who has been drawing and painting for years? You may often look at a lovely drawing or painting and have that mixture of awe, inspiration and . . . frustration. When you look at your own work and can see how far you've come but there's still something missing, that's when you pick up a book like this.

If you're a little more experienced than an absolute beginner, don't think there's nothing for you here. In this chapter you may find a few new tips you haven't encountered before that might just bridge that gap between what you've accomplished so far and what you're yearning to create in the future. And if you are an absolute beginner, you don't want to miss a page!

IN THIS CHAPTER

- Collect Your Materials
- Master Your Pencil Grips
- Explore Pencil Techniques
- Recognize Negative Space

Persian Cat
Graphite on paper
11" × 8½" (28cm × 22cm)

Explore extra bonus features by visiting **artistsnetwork.com/drawing-secrets-revealed-basics**.

7

COLLECT YOUR MATERIALS

The first material you probably think of is a graphite pencil. It's true that really all you need for drawing is a pencil, an eraser and a piece of paper. However, as you explore this exciting world of art and all the marvelous possibilities in drawing, you're going to want to stretch your wings. This section is a great starter kit.

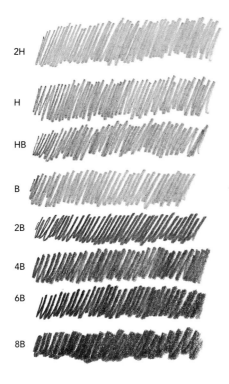

Graphite Pencils

You can draw and shade anything with just a regular HB pencil (an ordinary No. 2 pencil), but it's helpful to have a variety of hard and soft pencils. They provide a tonal range all the way from very hard and light (the H pencils) to very soft and dark (the B pencils).

The 2H or H is as hard as you will probably need for the lightest tones and the initial block-in, while an HB will give you a good mid-range, and B and 2B are good for darker shades. For very dark areas a 4B, 6B or even 8B is helpful. The softer the pencil, the sooner it will need to be sharpened. Familiarize yourself with the shading qualities of each of your pencils by varying the pressure of your grip. Re-create the tonal scale shown here with your own pencils.

Be aware that applying layers of graphite to get very dark tones will leave a sheen and sometimes a dent if you're pressing hard on your paper.

Other Graphite Pencils

Woodless pencils have the advantage of providing a wider shading surface because they are 100 percent graphite with no outer wood casing to interfere with the shading. Be careful because they break more easily. Laying them on their side will give you a wider swath of tone.

Mechanical pencils are convenient because they never need to be sharpened, and you can take them with you anywhere without worrying about the tips breaking. You don't have as much variety in graphite hardness or softness because they come in just three main thicknesses. From thinnest and hardest to softest and darkest, the available range is .5, .7 and .9.

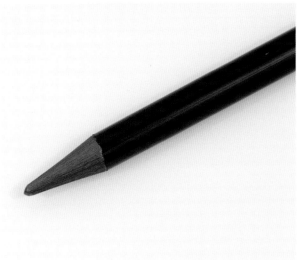

A woodless pencil tip. All of this is graphite, with only a thin lacquer coating.

CHARCOAL

Let's talk a bit about the types and features of various charcoal materials. Because this is a book aimed at beginners as well as more experienced artists, I'm going to share with you some essential information. You can explore further with these and other materials on your own.

Compressed Charcoal

In compressed charcoal, the charcoal is held together with a binder like wax. The more binder, the thicker and creamier the charcoal. Some charcoal pencils are chalkier and flakier than others. The compressed charcoal with more binder tends to lay very dark, solid tones on paper, with less of the paper tooth showing through. Unfortunately, most charcoal is not labeled "creamy" or "chalky." You'll just have to experiment on your own. Both kinds are useful, but note that the creamier the charcoal, the harder it is to erase, so it wouldn't be the best choice for initially blocking in a drawing.

Charcoal Pencils

Charcoal pencils are ideal for detail work such as portraits. Rather than leaving a reflective sheen on your paper as graphite does, charcoal absorbs light, allowing the marks to really settle on the paper. Charcoal pencils are graded differently than graphite. The pencils with the more chalky, compressed charcoal tend to come in soft, medium and hard grades or "dark" grades. The more waxy varieties have still other ways of grading. General's brand is helpful because it often provides a graphite grade equivalent like HB-hard or 4B-soft. Experiment with different charcoal pencils to see what works best for your drawings.

This pencil (Derwent Ivory Black 6700) has a creamier charcoal core, so the marks are thicker and smoother, and you can see a sheen on the charcoal tip of the pencil from the wax binder. This is the pencil you want to use when you're trying to get dark marks on more textured paper.

This pencil (Derwent 4B-soft) has a chalkier core from less binder, so the marks are dark but sketchy. This charcoal leaves dust and can smudge on your paper very easily. But this pencil also blends more easily and is easier to erase. Wash your hands frequently or place a piece of paper under your hand as you draw.

A white charcoal pencil is good for laying in highlights, which can be especially beautiful in portrait work on toned paper. They tend to be chalkier than Conté crayons.

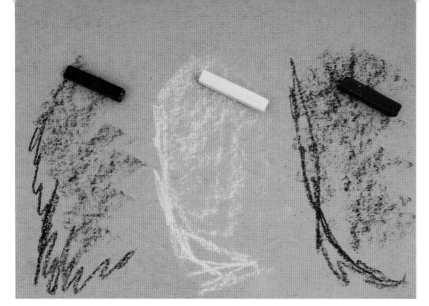

Conté Crayons

Conté crayons are slender, square sticks of compressed charcoal with enough binder to make them creamy as opposed to chalky. They typically come in natural pigments like black, white and sanguine (brick red) and are great not just for quick studies, but also for full-fledged portraits and drawings. Because they are square, they can be laid on their side for large areas of tone, while leaving sharp corners for finer lines and details. Go with the basic black, white and sanguine before exploring other pigments.

Willow Charcoal and Vine Charcoal

Charcoal in its base form is just charred wood. Willow charcoal, derived from willow branches, usually comes in a variety pack of thicknesses. With no binding agent, it erases more cleanly than creamier charcoal. It's good for drafting a drawing or painting before you get into details.

Vine charcoal comes from sections of grape vines so it is long and slender. It tends to be longer than willow charcoal but like willow, it erases more cleanly. Very delicate, vine charcoal forces you to work lightly, as you do when you're initially blocking in a drawing.

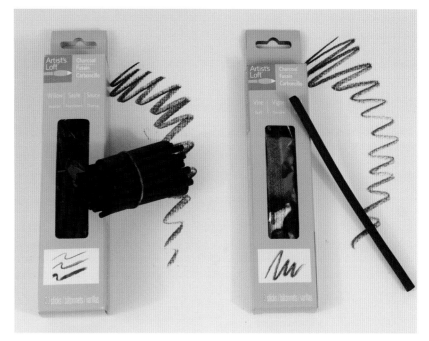

Thick Compressed Charcoal Stick

A thick compressed charcoal stick is just that—a thick stick of compressed charcoal that isn't too flaky or too creamy. It is perfect to break into short pieces and lay on its side for broad strokes such as in action and gesture drawings.

Graphite Stick

A graphite stick is like a compressed charcoal stick but it's made of graphite. It's thick and can be broken and used on its side as well. The difference is that it lays down graphite (same as a No. 2 pencil) instead of charcoal, which is great for laying down large areas of very smooth tone (not too dark or flaky).

PAPER

Drawing Paper and Toned Paper

You'll find a wide variety of drawing papers in any arts and crafts store. An 11" × 14" (28cm x 36cm) pad of general purpose sketch paper is perfect to start.

Instead of using white paper for faces and figures, toned paper is ideal because it more easily matches skin tone.

Newsprint

Newsprint is thin and inexpensive, so it's great for drawing exercises like action drawing. I recommend 18" × 24" (46cm × 61cm) because the bigger your paper, the more expressive you'll tend to be with your marks.

Copy/Printer Paper

I recommend using regular copy paper for most of the exercises in this book because it is cheap and plentiful, and will encourage you to feel free to draw, draw, draw without worrying about the cost of fine drawing paper.

Tracing Paper and Transparencies

You can learn a lot about proportions, lines and shapes using tracing paper. Transparencies come in handy to make picture planes.

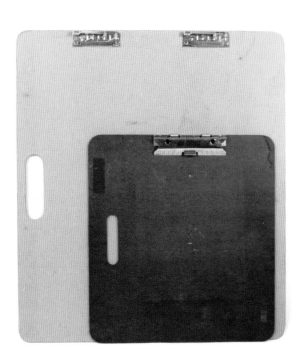

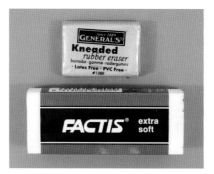

Kneaded Eraser and White Vinyl Eraser

A kneaded eraser is a rectangular piece of rubber in cake form. As you use it, it collects graphite. You can knead it so that it absorbs the graphite, leaving you a clean area to erase with.

A white vinyl eraser is useful when you need to remove hard-to-erase pencil lines because it is a bit more abrasive than a kneaded eraser but it won't smear the graphite.

Drawing Board

Also known as sketch boards or field sketch boards, these are large rectangular pieces of thin, hard, smooth Masonite or similar wood to rest your paper on as you draw. You can buy them in many art stores and they come in different sizes. For general purposes, I recommend one no smaller than 18" or 19" (46cm or 48cm). They come with clips to hold the paper securely.

To make your own drawing board, all you need is a piece of Masonite cut and sanded at your local hardware store. Then purchase chip clips or stronger clamps to hold your paper. And voilà! You have your drawing board.

Electric or Battery-Operated Eraser

An electric or battery-operated eraser can lift out very small, precise highlights in your drawing, such as the tiny highlight in the eye or accents on the nose, because the eraser is firmer than a kneaded eraser. It comes with refills and is easily cleaned; simply run it against blank paper or carpet.

Electric Pencil Sharpener

An electric pencil sharpener on your desk is great to keep your pencils sharp, and it requires only one hand. Many artists use a craft knife to customize how their pencil tips are sharpened.

Tortillion and Pad of Sandpaper

A tortillon (or paper stump) is a tightly wound paper cylinder tapered at one end to blend tones. Tones get darker when you use a tortillon and you can buy different sizes in a package.

A great little drawing secret is to keep a small pad of sandpaper close by because it keeps pencils sharp if you don't have a sharpener handy. It also gives you different edges to your pencil tip. You can buy sandpaper pads at most art stores, and they usually come with a number of removable sheets as the sandpaper wears down or gathers too much graphite.

Sewing Gauge, Ruler or T-Square

You've probably seen artists hold up a pencil or a paintbrush and squint with one eye. What they're doing is measuring relative proportions, a vital concept we'll cover in a later chapter. Some beginning artists prefer using a Dritz sewing gauge because it provides more exact measurements.

You will need a straightedge, such as a ruler, for many of the exercises contained in this book. An 18-inch (46cm) T-square is extremely useful for making vertical and horizontal axis lines.

Hand Mirror

It's important to check the proportions of your composition every now and then. A simple hand mirror that you may find at a pharmacy or grocery store is excellent for this. I'll show you how to use it in the section on my top drawing secrets.

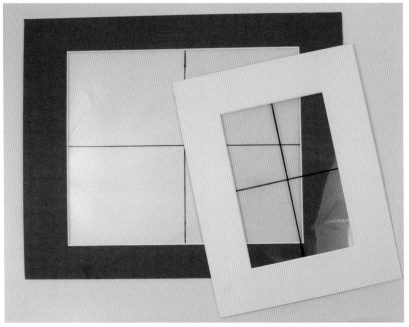

Picture Plane – inside dimensions 8" × 10" (20cm × 25cm) and 4½" × 6½" (11cm × 17cm).

Picture Plane

A picture plane is helpful for many beginning artists to achieve the correct proportion and perspective in their drawing. Even great Renaissance artists such as Leonardo da Vinci, Leon Battista Alberti and Albrecht Durer used forms of a picture plane. It's like a window flattening a complex three-dimensional subject into a two-dimensional image like drawing from a photograph.

A simple way to make one is to purchase a precut mat board from the framing section of any arts and crafts store. The mat board should have an inside measurement of no more than 8" × 10" (20cm × 25cm). On an 8½" × 11" (22cm × 28cm) transparency sheet, use a permanent marker to draw a vertical and a horizontal line crossing at the center of the sheet (these are your axis lines and this is where a T-square comes in handy), and tape or glue the transparency to the back of the mat board frame.

For this book, you will be working from photographs because photographs are easier for beginning artists to work from than life. Once you lay your picture plane over the photograph, you can instantly see which part of your composition goes in which quadrant. Therefore, the entire composition is broken down into manageable parts.

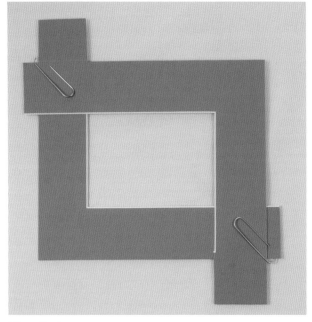

Viewfinder

A viewfinder is a useful tool to help you frame a good composition. Sometimes a composition, like a landscape, can be just too large or too complex to get a good focal point. You can buy a viewfinder in an arts and crafts store, but making your own is very simple. Just get a single mat board and cut it into two pieces, as shown. A couple of large paper clips should be sufficient to keep the pieces together, and you can adjust the viewfinder into any square or rectangular dimension you choose.

MASTER YOUR PENCIL GRIPS

There are several pencil grips to master to get the most out of your drawing experience. The first three are ideal for the beginning stages of drawing when you are using light marks to correctly place your subject. They encourage loose, expressive markmaking with light lines that are easy to erase. Give yourself an arm's length of space between you and your drawing board to allow for large arm movements. You'll use the first three grips interchangeably, depending on your subject and the size of your paper. By contrast, the fourth grip isn't used until you start getting into detail.

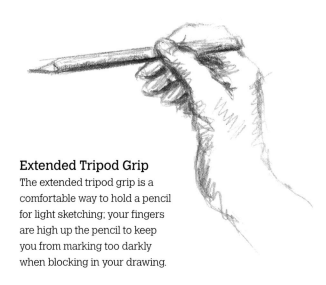

Extended Tripod Grip
The extended tripod grip is a comfortable way to hold a pencil for light sketching; your fingers are high up the pencil to keep you from marking too darkly when blocking in your drawing.

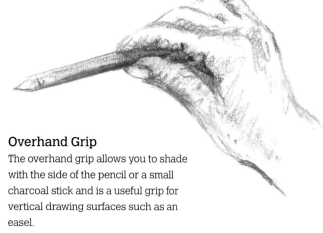

Overhand Grip
The overhand grip allows you to shade with the side of the pencil or a small charcoal stick and is a useful grip for vertical drawing surfaces such as an easel.

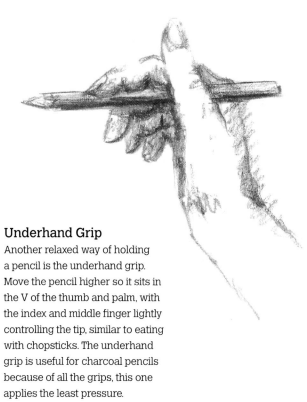

Underhand Grip
Another relaxed way of holding a pencil is the underhand grip. Move the pencil higher so it sits in the V of the thumb and palm, with the index and middle finger lightly controlling the tip, similar to eating with chopsticks. The underhand grip is useful for charcoal pencils because of all the grips, this one applies the least pressure.

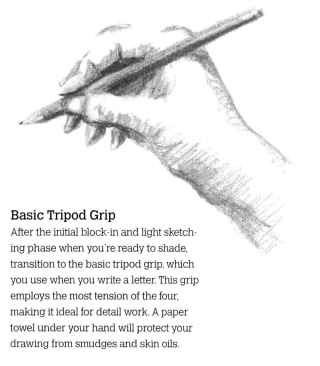

Basic Tripod Grip
After the initial block-in and light sketching phase when you're ready to shade, transition to the basic tripod grip, which you use when you write a letter. This grip employs the most tension of the four, making it ideal for detail work. A paper towel under your hand will protect your drawing from smudges and skin oils.

EXPLORE PENCIL TECHNIQUES

As you explore pencil techniques, you'll find H pencils are good for sharp line work, light shading and small areas. Because B pencils are softer and don't hold a fine point for very long, they work better for larger, bolder strokes. As I've mentioned earlier, the higher the B number, the darker the values. Graphite pencils, whatever the type, lend themselves to smaller papers, say under 9" × 12" (23cm × 30cm); charcoal is better suited for larger papers.

BROAD-STROKE TECHNIQUE

The broad-stroke technique is where the pencil lead is worn down on rough paper or sandpaper on one side until it has an angled point called a bevel. This tapering method takes advantage of the maximum width of the pencil lead, allowing you to have a flat surface point that can make broad strokes.

You will want to keep the pencil from turning because it has to be held in the same position for each stroke in order for the bevel to contact the paper the same way. However, it will give you a nice sharp thin line when you turn the pencil to the sharpened tip.

Bevel Edge

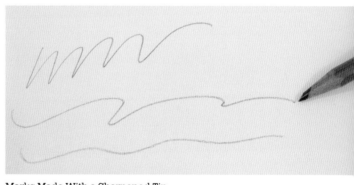

Marks Made With a Beveled Edge

TONE

Tone (also called value) refers to the degree of lightness and darkness in your drawing. There are various shading techniques where you can apply tone to give convincing mass and form to your drawing. You can use small, slanted or circular movements of the hand. The tone on this scale was achieved with a 2B pencil by keeping the strokes consistent while steadily lessening the pressure.

Marks Made With a Sharpened Tip

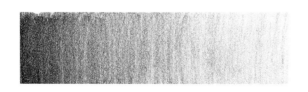

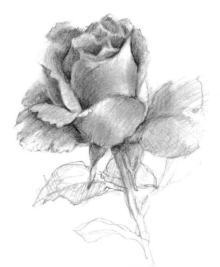

Lone Rose
Graphite on paper
8½" × 11" (22cm × 28cm)

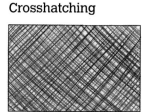

HATCHING AND CROSSHATCHING

You can always use your fingers or a tortillion to blend tones, but once in a while, try hatching or crosshatching. Hatching is a technique used to apply tone and shadows in rows of parallel lines usually drawn closely. Crosshatching is the crisscrossing of several layers of hatching in order to darken your tones.

You might find that setting your paper at an angle will be a comfortable position for you. Practice the hatching chart shown here with different pencil types and pencil pressures to get gradual and continuous shades.

Hatching

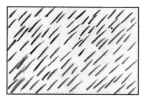

Crosshatching

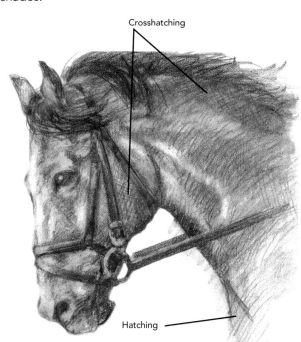

Crosshatching

Hatching

Crosshatching is used to darken the shadowed areas of the horse's hide and to indicate the curving surface of the thick neck muscles.

Hatching delineates the mane, while loose hatching allows the image to fade at the edges, thereby keeping the focal point on the head.

Horse's Head
Graphite on paper
8½" × 11" (22cm × 28cm)

Crosshatching Development

Hatching and crosshatching provide nearly limitless possibilities depending on:
• the utensil you're using, such as graphite pencil, pen or charcoal
• the pressure you exert
• the variety of hatch marks
• the curvature of the lines

Here you can see a basic progression of crosshatching using a 2B pencil. You can use a very hard, light pencil like a 2H or HB to hatch distant areas in a landscape drawing, or a variety of hatch marks with a 6B or 8B to achieve a heavy shadow.

Explore Pencile Techniques

DEMONSTRATIONS
HATCH FOR DIFFERENT EFFECTS

Although you'll be exploring more refined, thorough shading techniques in Chapter 3, hatching can give your drawing a vibrant, artistic vibe that imbues your work with energy.

FOR A CURVED SURFACE

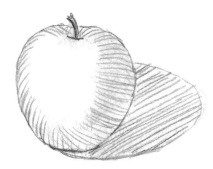 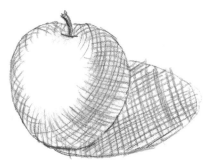 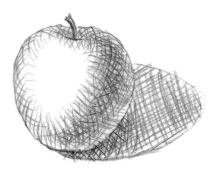

1 LIGHTLY HATCH THE SHADOW AREAS
Use an H pencil to lay in hatching across the whole shadow area including the shadow cast by the apple onto the table.

2 LAYER THE FIRST LEVEL OF CROSSHATCHING
As the shadow deepens, the layers of crosshatching will increase. Just inside the shadow border, where it gets darker, add a layer of crosshatching following the curve of the apple.

3 DEEPEN THE DARKEST SHADOWS
With a 2B pencil, layer a third hatching line opposite the hatching line direction from step 2. This deepens the darkest areas.

FOR AN ANGLED SURFACE

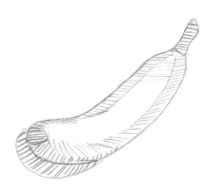

1 LIGHTLY HATCH THE SHADOW AREAS
With an H pencil, lay in hatch marks across each of the shadow areas. Observe which shadow areas are darker than others, and hatch accordingly by applying more or less pressure on the pencil.

2 LAYER THE FIRST LEVEL OF CROSSHATCHING
Crosshatch over the shadow areas, increasing your pencil pressure for the darker areas.

3 DEEPEN THE DARKEST SHADOWS
Using a 2B pencil, add another hatching layer to the darkest areas: around the stem, the shadow cast on the table (especially the area where the banana meets the surface of the table) and the bottom end of the banana.

RECOGNIZE NEGATIVE SPACE

A common misconception is that negative space must be the dark areas of a drawing or picture, and the light areas must be the positive space.

Not always. Quite simply, the positive space is the object (or objects) in a composition. The space around the object(s) is the negative space.

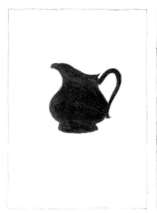 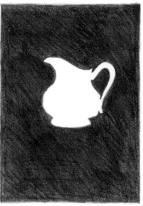

You can see from the simplified example here that you can have a dark pitcher on a light background or a light pitcher on a dark background, and in both cases the pitcher is the positive space.

So why is the concept of negative space a useful one? If you're having trouble rendering the positive space in your composition, try switching your focus to the negative space around it. This can help reduce the whole composition to abstract shapes that can be simpler for the mind to grasp.

In this negative space drawing, you can tell the image is actually of a chair although the only marks on the paper are the shading of the negative space. What's interesting is that even though the perspective is up high and to the side, and it obscures two legs and an arm, you can still readily distinguish that it is a chair. This is because, while you may not be aware of it, your brain is always working to make sense of the world around you, even if it doesn't always have the correct names or lines for it.

This grove of trees is a good exercise for training your eyes to observe negative space. Focusing on the negative space between the trees and the branches can actually help you form your positive space accurately. And remember, negative space can be any color, not just dark gray or black. See if you can find where the three negative shapes on the right show up in the main composition.

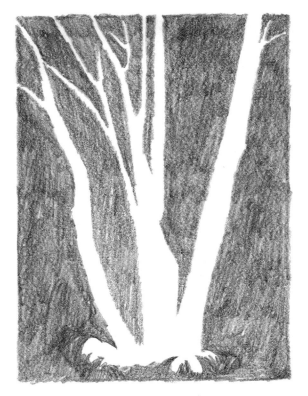

MY TOP DRAWING SECRETS

Of all the information I could give you, these are my best tips. If you incorporate these into your everyday practice from the start, your drawing will improve by leaps and bounds!

SECRET #1 USE AN EASEL OR DRAWING BOARD

Hunching over your table with your eyes a few inches from your paper makes it nearly impossible to detect errors in proportion and perspective as you're beginning your drawing. You need distance for that. A standing easel is the ideal drawing surface where your paper can be perpendicular to the floor and parallel to your eyes. But if you don't have an easel, you can use a drawing board as long as it is propped up as straight as possible, such as against the back of a high-back chair. Any slant will cause visual distortion, so do your best to eliminate it. Once you begin shading, you can move closer to your drawing, but distance and the right paper angle are key when initially drafting your drawing. Keep your easel or drawing board at arm's length during the entire block-in phase . . . which leads into the next drawing secret.

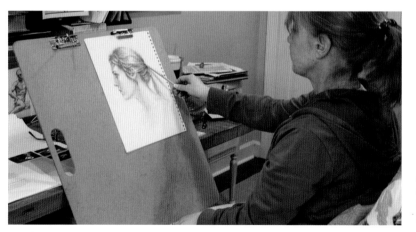

SECRET #2 USE LARGE, LOOSE ARM MOVEMENTS

In the beginning stages of a drawing, use large, loose arm movements, preferably using an H or HB pencil (lighter strokes are easier to erase) in a loose pencil grip, such as an extended tripod or overhand. Large arm movements let you get your whole composition blocked in before starting detail work.

SECRET #3 STAND BACK AND GLANCE BACK AND FORTH

Throughout your drawing, take a break and stand back several feet, glancing back and forth between your drawing and your reference image many times. This gives you fresh eyes, the same as if you left your drawing for a while and came back, so you can see if it's accurate. If you don't do this, you'll find out the hard way that you inevitably end up with a drawing shaded so heavily it leaves a ghost image that you can't fully erase. I recommend using this secret throughout your drawing sessions—especially before you start heavy shading.

SECRET #4 LOOK AT YOUR SUBJECT AT LEAST HALF OF THE TIME

A good rule of thumb is to look at your subject at least half of the time. It's tempting to get involved in all the fun details of your drawing, but if you don't remember to keep your eye on your subject then you may become too engrossed and get into trouble with value, proportion and/or perspective.

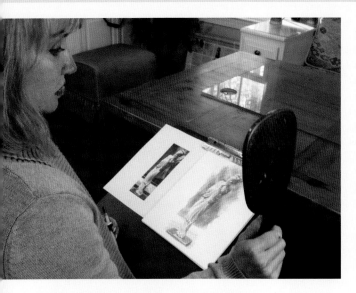

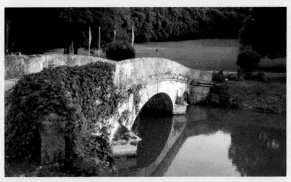

Before Squinting

After Squinting

SECRET #5 USE A MIRROR

I have a full-length mirror placed behind me while I work at my easel so I can see both the sitter and my painting in a single view. If you don't have a full-length mirror, use a hand mirror often throughout your drawing sessions to check your work. Turn away from your drawing, hold up a mirror over your shoulder and twist a little so you can see both your drawing and the subject in its reflection. Then compare the two back and forth. Make sure the mirror is parallel to the drawing to reduce visual distortion. You'll be astonished at how many flaws jump out at you in the mirror that hide from you when you look straight at your drawing. Staring at one thing for a long time habituates your eyes to it so that you can't distinguish weaknesses as well. Using a hand mirror will achieve the same result as if you left your drawing for a day and came back with fresh eyes.

SECRET #6 SQUINT AT YOUR SUBJECT

All good artists learn to squint at their subject, whether they are drawing or painting. This simplifies the scene into large value masses (the light and dark tones) without detail. Since light defines objects, you will begin to see objects as abstract shapes. Getting the large masses on paper quickly, with light hatching, will help you get the correct placement and tone of these images.

It will also help you observe which edges are hard and which edges can blend into the background. These are your lost-and-found lines which can elevate your drawing to a more sophisticated level. Squinting is not used to determine color, but it can help you determine the tones of those colors in your subject.

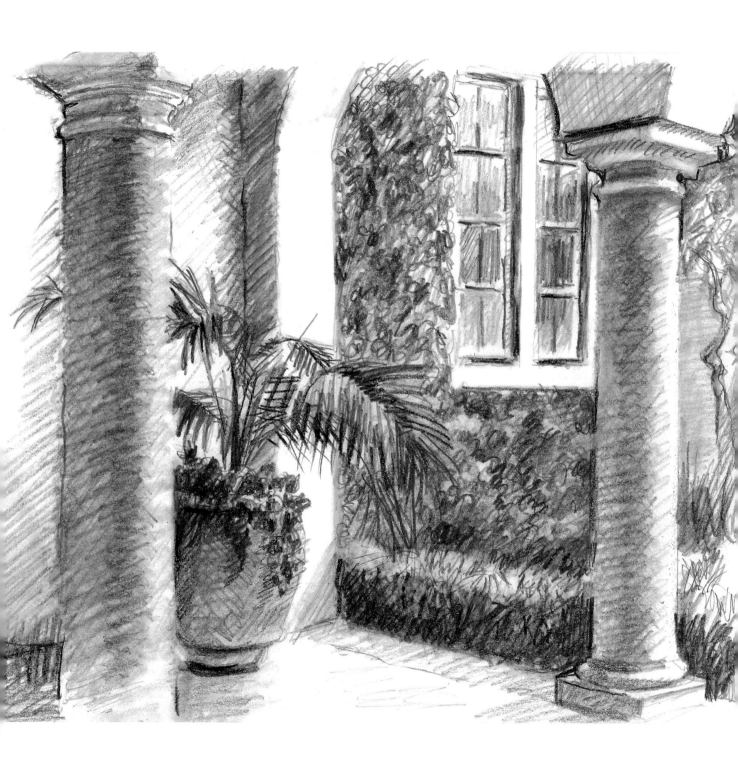

2 BUILDING COMPOSITIONS
WITH BASIC SHAPES

Light and shadow describe all objects, and we can see and recognize those objects by how the light illuminates them. A good artist can create the illusion of three-dimensional objects on two-dimensional paper by recognizing the direction of the light source by the shadows the object casts, and by understanding the elements of lighting.

Drawing and shading basic geometric shapes is critical training for you as an artist because so many objects in life can initially be described by those basic shapes. You'll get better at not only identifying those shapes in real life, but accurately rendering the elements of lighting for differently shaped objects. Look around your home and you'll find plenty of objects that have the angular surfaces of a cube or pyramid, or the softer rounded surface of a spherical or conical object.

Another important take-away from this chapter is to understand that your elements of lighting will be different if your light source is singular or multiple, close or far away, high or low, etc. Also your light source illuminates differently shaped objects differently; a stationary light source casting the exact same light will create different shadows on a cubical form than on a round form.

Understanding how all these concepts work together as they change with every composition is important foundational work.

Courtyard Columns
Graphite and charcoal on paper
11" × 8½" (28cm × 22cm)

IN THIS CHAPTER
- Identify Basic Shapes in Your Composition
- Recognize the Elements of Lighting
- Render Shapes Realistically

IDENTIFY BASIC SHAPES IN YOUR COMPOSITION

Everywhere you look you can see examples of the basic shapes: cube, oval, rectangle, sphere, hemisphere, cone, cylinder, hexagon and pyramid. When looking at a complicated object or composition, it helps to reduce it to its basic shapes.

The ability to discern the basic shapes of your subject enables you to easily block in your drawing to get the shapes placed and sized correctly on the page. Once you have sketched in the basic shapes, you can start to incorporate some initial shading and details,

but we'll get to that in a later lesson. This kind of drawing exercise is so beneficial in training your eyes to see like an artist! I encourage you to do it with any composition you see. Start simple first, as you can see below, and then gradually work on sketching the basic shapes of more complex, multi-object compositions. The more you do it, the better your brain will tell you which shapes and lines to lay down on your paper first.

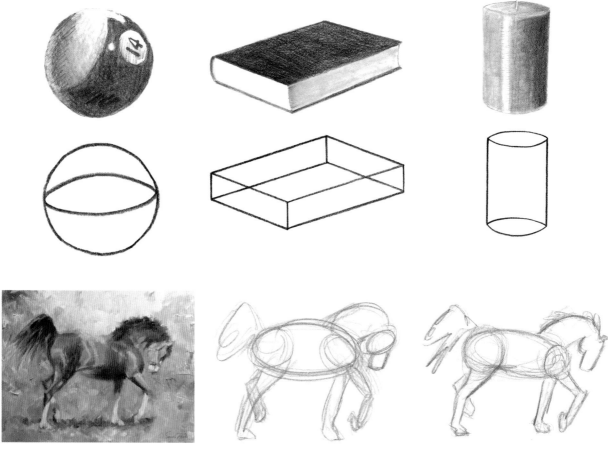

1 REFERENCE PHOTO
Squint to help you find just the main basic shapes of the horse. You're not getting into any detail here.

2 ROUGHLY INDICATE THE BASIC SHAPES
Block in a few basic shapes like ovals, triangles and cylinders. There will be overlapping, imprecise lines and not a lot of erasing. Use a light, loose pencil grip.

3 JOIN THE SHAPES
Erase some of the hidden lines (the lines you don't see in the reference image) as you refine the horse. The sketches are still rough, but more of the true form is emerging from those circles and triangles.

RECOGNIZE THE ELEMENTS OF LIGHTING

Once you can reduce subjects to their basic shapes, realistic shading techniques can flesh them out and bring them to life. Understanding the main elements of lighting will help you render light and shadow effectively. This is absolutely essential to grasp in order to give your drawings three-dimensionality. The first step is to determine where the light is coming from because light informs all objects. Then incorporate the following five elements of lighting. These elements of lighting will be more defined with a single, strong light source, as in the example shown here.

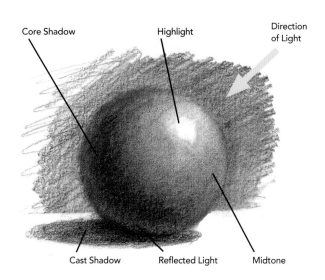

Core Shadow · Highlight · Direction of Light · Cast Shadow · Reflected Light · Midtone

HIGHLIGHT

This is where the light source is hitting the object directly. It will be the lightest light of the whole shape and the closest area to the light source. The highlight will be lighter and more defined on a shiny surface than on a matte surface.

MIDTONE

This is the area between the highlight and core shadow, and shows the gradation of darkness as the object curves or slants away from the light source.

CORE SHADOW

This is the darkest dark on the shape itself and receives the least light from the light source. This is the area caught between the highlight, midtone and any reflected light.

REFLECTED LIGHT

When an object is sitting on a light surface, the light will reflect back up onto the bottom of the object. This is reflected light. This will be darker than the highlight but lighter than the core shadow. Depending on your composition, it may not always be visible.

CAST SHADOW

This is the shadow cast onto the surface on which the object is sitting. The shape of the cast shadow will change drastically depending on where the light source is positioned. The lower the light source, the longer the shadow.

TIPS

With every shift of the light source, the placement of these various elements of lighting will shift, too. Try it yourself. Choose a single, simple object and in a dim room, shine a flashlight on it from one direction. Move the flashlight around (closer and farther away, higher and lower), noticing how the elements of lighting change.

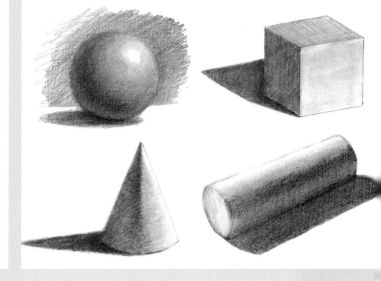

ELLIPSES

Anytime you are not looking straight on at a circular shape, such as a cylinder, that circle will appear oval. An ellipse is technically an oval shape, but that can mean a dozen variations as your perspective changes. The same applies to shadows. Let's say you're sketching a sphere. Even if the light source is directly above, making the actual cast shadow in fact a circle, you won't be drawing from directly above, so your drawing of the round shadow will be an ellipse. Many factors affect the shape of the shadow, especially how high or close the light source is. The highlight will depend on where the light source is, and it will shift in proportion with the shadow.

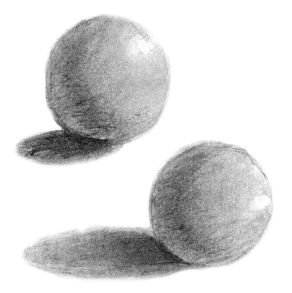

With the sphere on the top left, the light source is high, so the highlight is high and the shadow is short, more of a circle than an ellipse. For the sphere on the right, the light source is low, so the highlight is low and the shadow is a long, very pronounced elliptical shape.

And that difference, if not rendered accurately, will be noticed—often subconsciously—by your viewer.

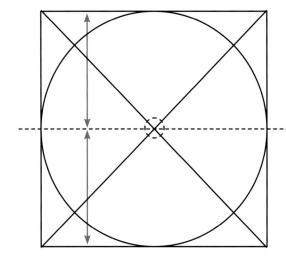

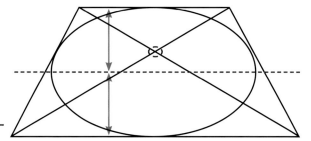

The dotted red line represents the actual halfway point between the front and back of the circle. The red circle represents the visual halfway point. In the first diagram, the visual and actual halfway point between front and back borders of the square fall at the same place. In the second diagram, you can see the midpoint appears farther back as your perspective becomes more distorted.

Ellipses don't show up in cast shadows alone. When drawing objects that have circles, such as the rim of a candle, unless you are drawing from directly above, you will draw an ellipse. And depending on your perspective, as you come nearer, the exact shape of that ellipse will change, getting flatter as your perspective lowers.

THE ELEMENTS OF LIGHTING IN REAL LIFE

To illustrate how these principles can be used in real life, we can see that the human head often shows shading similar to a sphere or a cylinder if strong light is coming from a certain direction.

In the photograph, a strong light is coming from the right and a softer, secondary light source appears from the lower left. You can see the core shadow on the cheek. You can see her chest is reflecting a subtle rim of light on the underside of her chin below the core shadow.

I did this painting from that photograph. You can see why understanding these elements of lighting is so important, not just for drawing but also for any color medium. So if you're interested at some point in progressing to painting, invest time, energy and practice in developing your drawing skills.

Now that you have a fundamental understanding of the elements of lighting, let's get started with a few demonstrations that focus on basic geometric shapes. Such practice will build a good foundation for you to draw any shape in life. I always say you have to learn the rules first in order to know how to tweak them. We'll learn these rules with a sphere and cube.

Core Shadow Midtone Highlight

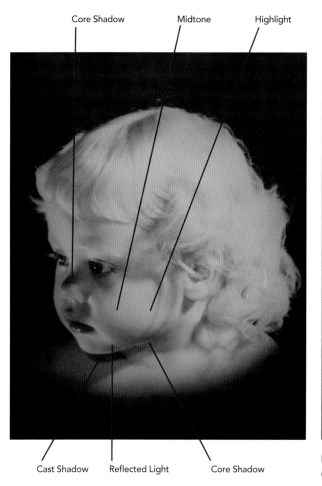

Cast Shadow Reflected Light Core Shadow

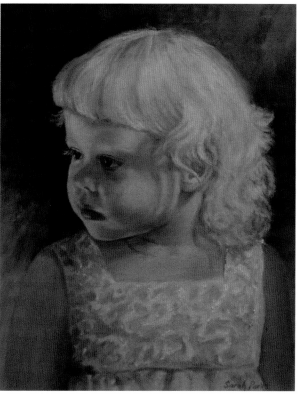

Baby Sally
Oil on canvas
20" × 16" (51cm × 41cm)

RENDER SHAPES REALISTICALLY

DEMONSTRATION

DRAW A SPHERICAL SHAPE

In this demonstration of how to shade a sphere, the light source will be coming from the right. To draw forms, you must always identify what direction the light is coming from first, then you can shade it by carefully examining the various tones and the reflected light and highlights. For all of these demonstrations begin with an H or HB pencil.

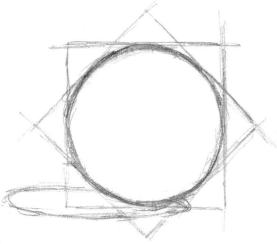

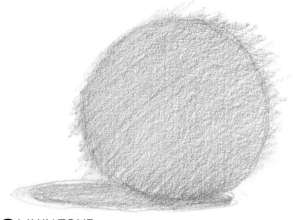

1 DRAFT YOUR SPHERE
To draw a good circle, use an H or HB pencil to lightly draw two overlapping squares to orient your circle. Then erase the squares and lightly sketch an ellipse for the cast shadow.

2 LAY IN TONE
The elliptical cast shadow is seen clearly on the light-colored tabletop. Switching to a 2B pencil, lightly shade the entire ball. Clean up the borders with your eraser. The tone over the whole sphere should be consistent.

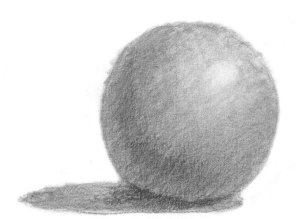

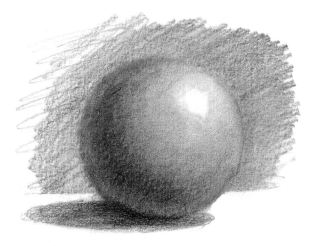

3 BUILD THE ELEMENTS OF LIGHTING
Begin to vary your pencil pressure to darken the core shadow and keep the highlight and midtone lighter. Be very aware of your light source, which is very high and toward the front (giving you a defined, complete highlight). The elements of lighting are beginning to emerge.

4 REFINE THE ELEMENTS OF LIGHTING
Using a 4B pencil, crosshatch to darken the core and cast shadows, especially under the sphere. Dab the highlight with your kneaded eraser to lighten it. Let the reflected light coming up from the tabletop fade as the sphere curves away from the tabletop.

DEMONSTRATION
DRAW A CUBICAL SHAPE

Cubical shapes can be challenging to draw because there is some measuring and analysis. It's important to get the parallel lines truly parallel. If they're off even a little, the whole shape looks lopsided. A cube is a good shape to practice because so many things in life are cubic shapes: buildings, books, furniture, storage containers and boxes.

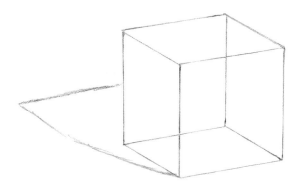

1 LAY THE FOUNDATION OF YOUR CUBE
Draw a vertical line 2" (5cm) long, measuring with a ruler or T-square to make sure the line runs parallel to the paper edge. About 2" (5cm) beside it, draw an identical parallel line a little lower on the page to account for the perspective. Connect those lines with a second pair of parallel lines.

2 BUILD YOUR CUBE
Draw an identical offset square a little above and to the left of the first face. This will be the back of the cube. Glance back and forth several times to make sure the second face is positioned correctly. Then join both faces with parallel lines to construct your cube. Lightly outline the cast shadow.

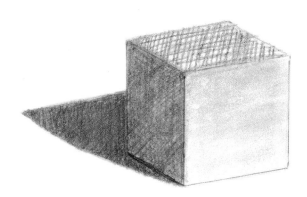

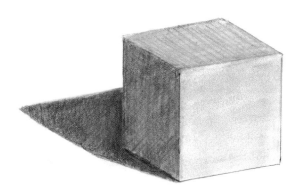

3 SHADE YOUR CUBE
Squint when comparing the values of your drawing with your reference image, and you'll see there are four main values: each of the three faces and the cast shadow. Hatch the top and side with a 2B pencil. Use a 6B pencil for the cast shadow. Because the front face is so light, almost white, instead of using a pencil, wrap a piece of tissue around your fingertip and rub it in one of the darker areas. Then smear this very light layer of graphite over the front face.

4 REFINE WITH A TORTILLION
Use a tortillion or your tissue-wrapped finger to further develop your shading if you want it to look more finished than the previous step. Leave a few hatch marks if you like. If your tortillion darkens an area too much, press your kneaded eraser onto that area to gently lift out some graphite and, if needed, lay in a few new hatch marks with a lighter pencil before blending again.

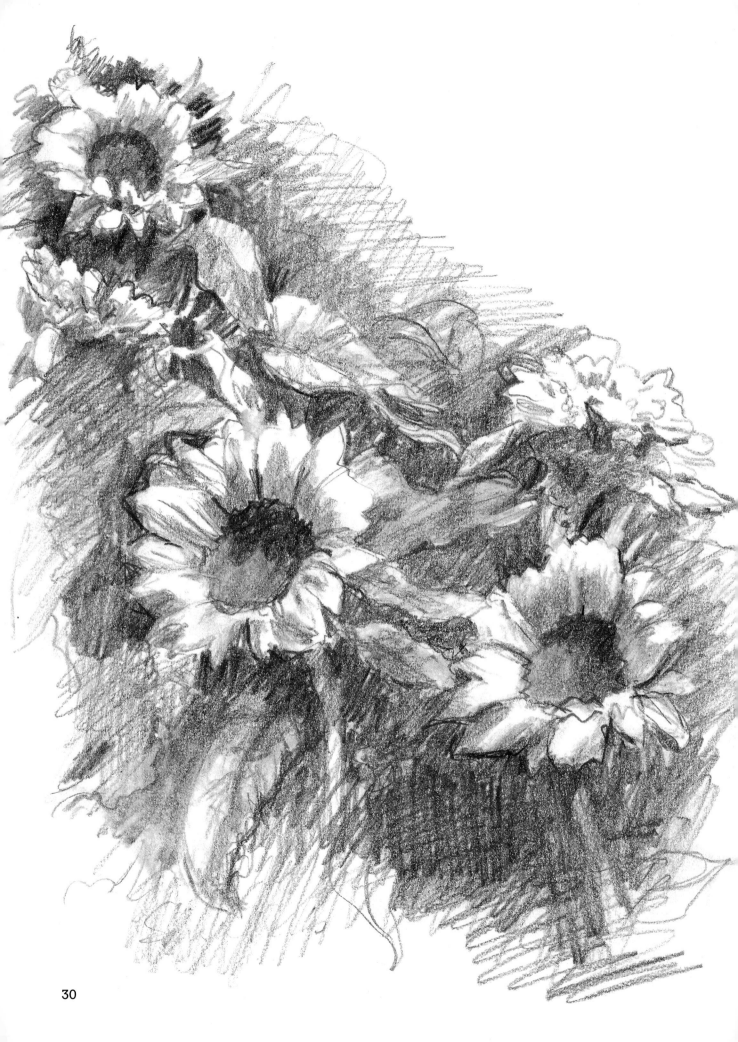

3 BLOCK-IN & SHADING:
THE BEGINNING & END OF YOUR DRAWING

The biggest hindrance to students' progress that I've seen in my years of teaching is that they usually start small and then try to expand their drawing to fill the page. They inevitably get the proportion and scale wrong because they are working from small to large. When drawing a face, they start with the eye; when drawing a flower, they start with a petal. Focusing on details early in the process is a lot of fun, but it invariably turns out a drawing that doesn't look right because the drawing has an off-balance foundation for those details to build on.

You have to start big and work small, which is why skilled artists always start their drawings with a block-in. Not only does blocking in a drawing ensure you will get your drawing correctly placed so it doesn't run off the page in any direction, it also breaks up even a complex image into manageable parts, which trains your eye to analyze and observe shrewdly. If you rush into heavy shading and detail before you've done a proper block-in, then any erasures will leave a ghost image.

While there are a variety of methods for blocking in drawings, I'll show you the most straightforward and helpful technique for beginning artists. It will enable you to lay the foundations of your drawings before you get too invested.

IN THIS CHAPTER

- Block In Your Drawing
- Alternative Block-In Techniques
- Shade Your Drawing With Sophisticated Realism

Sunflowers
Graphite on paper
11" × 8½" (28cm × 22cm)

BLOCK IN YOUR DRAWING

While you can use this block-in technique with any real-life, three-dimensional composition, it's enormously helpful to learn it with a photograph first. For beginners, a two-dimensional image is easier to work with. You'll block in a very simple composition of two pears against a plain background to give you a foundation for blocking in the more complex subjects in this book.

DEMONSTRATION
STANDARD BLOCK-IN TECHNIQUE

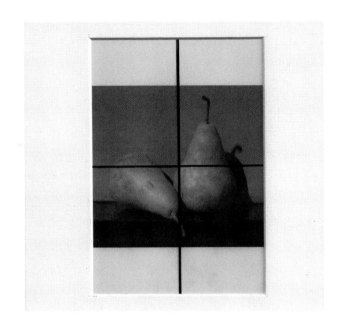

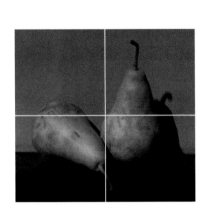

1 PREPARE YOUR PHOTOGRAPH
Whenever you're blocking in a drawing, change your reference photograph to grayscale, if possible. This removes the distraction of color and allows you to focus on the light and dark areas.

Draw vertical and horizontal axis lines on your photograph. (A T-square will get them perfectly perpendicular.) Because a block-in begins with axis lines on your drawing paper, doing so helps you correlate the subject with your drawing as you progress. Or, if you don't want to mark up your photograph, simply lay a picture plane (mentioned in Chapter 1) over your photograph.

2 PREPARE YOUR PAPER
With an H pencil, lightly draw vertical and horizontal axis lines on your drawing paper. You may want to draw some frame lines as a visual border so your image doesn't run off the page in any direction. Frame lines are especially helpful when your subject is not going to fill the entire paper.

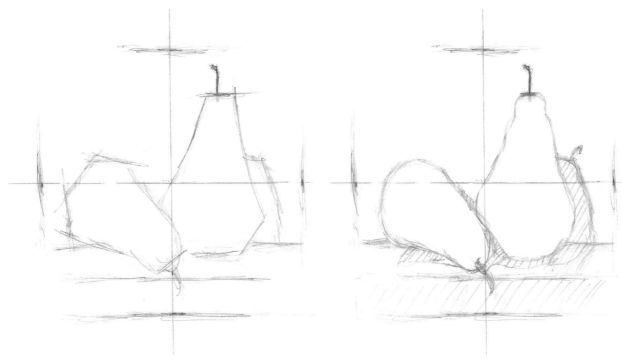

3 BLOCK IN YOUR SUBJECT WITH STRAIGHT LINES

Roughly block in the pears with straight lines just to suggest the shapes. Include shadow shapes as well. This is to make sure you have it placed the way you like on your paper, so no details are necessary here.

Make sure you are glancing back and forth frequently between the reference image and your drawing as you block-in to compare the placement, size and distances! Also, If you're working from a small photograph and filling a larger paper, your axis and frame lines will help you change the size of your drawing. This is called *changing scale*.

4 OVERLAY MORE CURVED LINES

Once the overall placement is accurate, erase your straight lines slightly and sketch in more curved lines. Be aware of the distances from various parts of your objects to the axis and frame lines, which are your main reference points.

Although you're not getting into shading yet, you can loosely hatch in your shadow shapes to begin differentiating between the objects and their shadows. At this point, your block-in is finished and you're ready to move on to shading, which you'll do in a later demonstration.

.

TIPS

PAY ATTENTION TO NEGATIVE SPACE

Make sure you pay attention to the negative spaces as you're drafting your positive shapes. Especially in these initial steps of sketching straight, then curved lines, noticing the abstract shapes of the negative spaces helps you get the shapes of your positive spaces right. Just like your overall composition, the negative space is broken down into more manageable pieces by the axis lines.

In the top image, I've shaded in just a few of the negative spaces compared to the image below, where all the negative space is indicated.

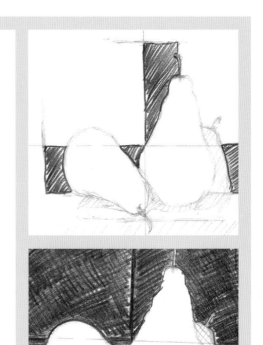

FINISHED BLOCK-INS

It can be difficult to distinguish when the block-in is finished and you're ready for shading because a block-in doesn't look finished. How can you tell?

Basically the block-in stage is finished when you have the composition placed correctly on your paper with proper proportions but no dark shading or details. It's extremely important at this point to use your hand mirror technique or glance back and forth quickly about ten times. If there are any problems with proportion or scale, now's the time to change them. You don't want to make those changes after heavy, dark shading and carefully drawn detailing. This is the point where you want to proof your work closely. Don't rush this step.

Here are some more examples of finished block-ins that are ready for shading to help you recognize the point the block-in is complete and you're ready to refine and finish your drawing.

Notice

The iris block-in doesn't have heavy shading, the background is not laid in and the axis and frame lines haven't been erased yet.

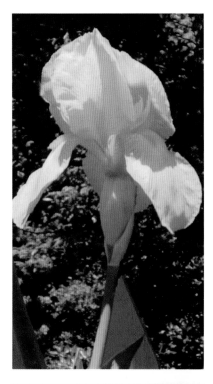

Notice

The block-in of the girl has no shading, the background is not laid in and the straight lines haven't been erased yet.

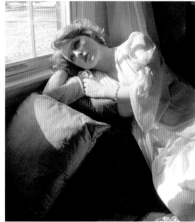

ALTERNATIVE BLOCK-IN TECHNIQUES

Sometimes you'll find as you explore different compositions and build your skills that your needs change, so here's an alternative block-in technique.

FIND THE MIDPOINT

Sometimes when you have a tall, narrow subject like a person or a lighthouse, or a long, shallow subject like a boat or a reclining figure, you really need to know only the height or the width. You might also have a long, diagonal subject. In all these instances, you may find that using your two axis lines and four frame lines to observe each quadrant of your subject is unnecessary. When drawing a standing figure, for example, your more pressing issue is to correctly gauge the height of the figure so the head or feet are not cut off. But once you gauge that correctly, you don't have to worry so much about the width of the subject running off the page. So that's where finding the midpoint is helpful. It's just one reference point as opposed to the two you get with vertical and horizontal axis lines.

You'll use the photograph of the chair for a vertical subject and the photograph of the medieval chest for a horizontal one. Use an H or HB pencil for these block-ins.

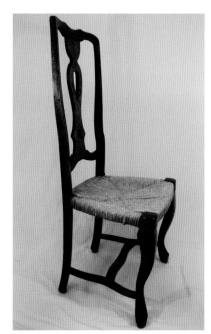

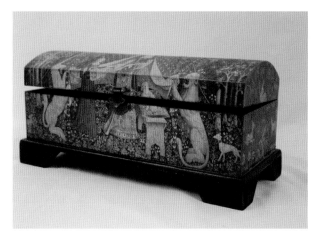

DEMONSTRATIONS
FOR A VERTICAL SUBJECT

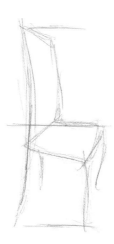
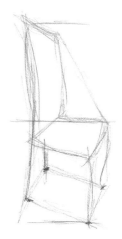

1 PREPARE YOUR PAPER
With very light lines, mark the top and bottom frame lines to contain your image. Mark your midpoint on your paper with a light horizontal line.

2 ORIENT YOUR SUBJECT
Determine the midpoint of your subject (about the top of the seat) so you can align that midpoint with the midpoint on your paper. Glancing back and forth often, draft the shape of the chair with light, sketchy lines that will be easy to adjust.

3 CHECK YOUR SUBJECT
Lightly draw the outer envelope of the whole subject with straight lines. This helps you visually check your lines and shapes. Doing this led to several adjustments: the back left leg was shortened and all four legs were realigned. Your block-in is finished at this point.

FOR A HORIZONTAL SUBJECT

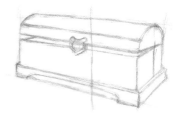

1 PREPARE YOUR PAPER
Lightly mark the right and left frame lines so your image doesn't run off the paper. Mark your midpoint.

2 ORIENT YOUR SUBJECT
Visually determine the midpoint of the medieval chest in the photograph. It's at an angle and on the diagonal tilted away from you, so the midpoint is not right at the clasp and the left end is smaller than the right because of the laws of perspective.

3 CHECK YOUR SUBJECT
Glance back and forth many times to compare various points of the shape. The perspective of the chest will drive most of your adjustments.

SHADE YOUR DRAWING WITH SOPHISTICATED REALISM

Before you continue, let's stop a moment to talk about values. As I've mentioned previously, values are the lights and darks of an image (also called tone). But they can be trickier than you think, especially if you're working from color images, which is why I recommend changing your reference photograph to grayscale. The human eye sees more in terms of value than it does in terms of color. You look at a complex landscape and you think you know you're looking at trees or grass by their color, but if it were photographed in black and white, you'd still understand that they are trees or grass because of their shapes, which are defined by values.

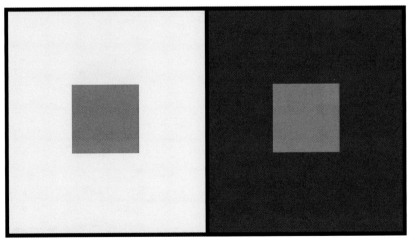

Let's test your observation skills.

Look at the image to the left of two large squares with a smaller square in each one. Would you say the left inner square is lighter or darker than the right inner square?

The answer is both of the inner squares are the same values, as I'll explain on the next page.

DEMONSTRATION

MAKE A VALUE SCALE

Holding up a value scale to a particular shade is a real eye-opener. Here you see a 10-point value scale with a long bar of Value 5. That Value 5 looks much darker under a Value 1 than under a Value 10, but it's all the same value.

While you can easily find a value scale online or buy one in an art store, I recommend making your own because you build muscle memory as you learn what types of pencils and pressure create the various values. The process also trains your eye to accurately evaluate values.

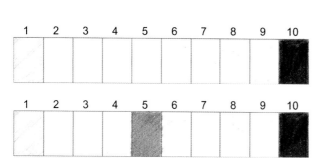

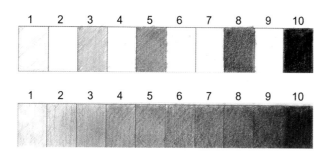

1 MAKE YOUR TEMPLATE
Draw ten 1" (3cm) boxes next to each other in a line and number them 1 through 10. You can easily make this template yourself. Use cardstock to make it more durable.

2 ORIENT YOUR VALUE SCALE
With the basic tripod grip, use an H pencil to very lightly shade the first box for the lightest, almost white value (1). Use an 8B and heavy pressure for the darkest value (10). The two shades provide a comparison for all the values in between. Then take a 2B pencil and shade in box 5 with a midtone range that you estimate to be between 1 and 10.

3 FILL IN THE REST OF THE BOXES
Varying your pencil pressure and pencil types accordingly, fill in the rest of the boxes to show a gradation in tone. It may help to shade in the middle box between the already shaded boxes, rather than to go in numerical order. It's easier to estimate the middle value between 1 and 5 to get a 3, rather than to go straight to the 2 and estimate that. You should see an even progression from box 1 to box 10. When you're finished, cut out the template.

TIPS

- You may need to use a tortillion to achieve the right values.
- An electric eraser is great for cleaning up the borders as you go.
- Use a hole punch to create a hole in the center of each box. This can make comparing values easier because the value of what you're looking at shows through the hole and is surrounded by the value box. This is an especially helpful tip with color images.

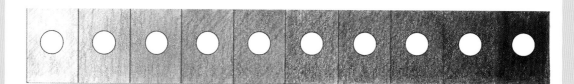

SECRETS FOR DRAWING REALISTIC VALUES

SECRET #1 PHOTOREALISM

If photorealism is your aspiration, try not to use dark outlines because there are no lines in nature—only dark and light values butting up to each other in contrast. You want your drawing to have three-dimensionality like nature itself. Of course, outlining (along with lost-and-found lines) can provide interesting effects outside of photorealism.

SECRET #3 SHADE THE BACKGROUND

In general, our eyes are trained to focus on the foreground and the positive space. But understanding and laying in the background can make all the difference because the values of the background directly affect the perception of the values of the foreground. So shade in the background fairly early in your drawing. It's very easy to shade your foreground too lightly or too darkly if you don't have an accurate contrast with the background.

SECRET #2 BUILD UP WITH SHADING

Use light lines to get the basic outline, then define shapes by building up the shading. Your tonal values should be closely observed and drawn well, but remember you can't perfectly replicate nature's values. Try not to obsess.

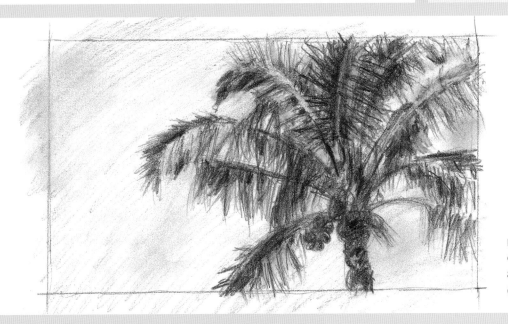

Palm Tree
Graphite on paper
8½" × 11"
(22cm × 28cm)

SECRET #4 SQUINT AND SHADE

Shading is fun, but many amateur artists tend to overdo their values by darkening or lightening them too much, which does not render a realistic drawing. Use your value scale and squint at your subject whenever you are shading!

HOW TO USE YOUR VALUE SCALE

Once you've made your value scale, you can use it anytime you're ready to begin shading. All you do is hold your value scale up to a scene to judge the values as you draw. Move it up and down, squinting, until you find the best match. You can see that the value of the shadows on the mountainside range from about a Value 6 or 7 toward the bottom, as that area catches some of the light, to a Value 8 or 9 up toward the ridge where the sunlight is cut off. Then lay your value scale against the corresponding areas of your drawing to see if your values are accurate.

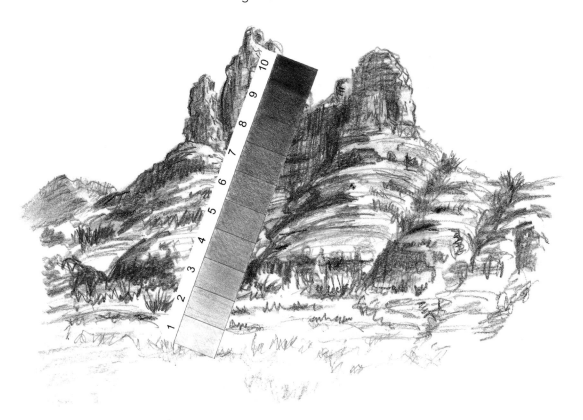

Desert Mountains
Graphite on paper
8½" × 11" (22cm × 28cm)

In my drawing of a pond, you can see where I incorporated different values. The shadows of the marsh grasses and trees are very dark, in the range of Values 8–10, while the water is much lighter.

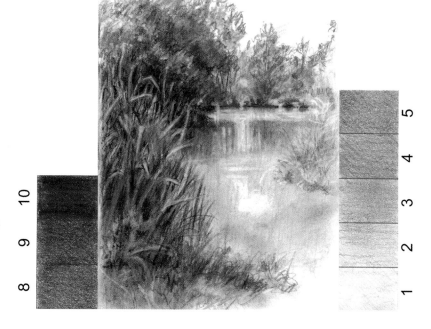

USING YOUR VALUE SCALE WITH COLOR SUBJECTS

Although a value scale is made up of shades of gray, you can still use it on color images. Sometimes color can confuse an artist who is trying to grasp what values the image encompasses.

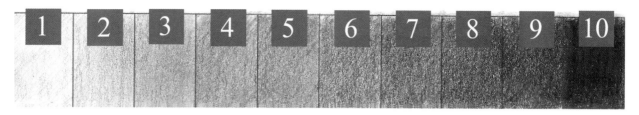

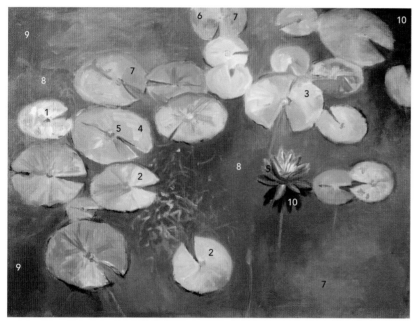

Lily Pond
Oil on canvas
22" × 28" (56cm × 71cm)

You can see where different values are numbered on this painting that I did of a lily pond. At first, you may still struggle to confirm those numbers because even looking back and forth between the value scale and the painting, your eyes can be confused by all the color. Your eyes will become better trained to simplify colors down to values if you squint.

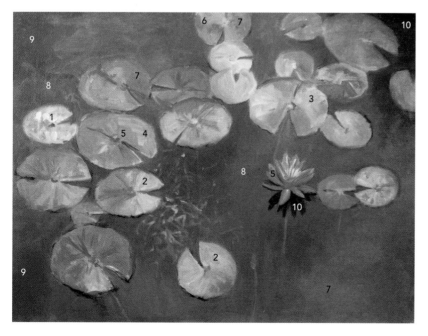

Here's a grayscale version of the diagram to help train your eyes. The best way to confirm this is to lay your value scale against various spots in the picture. When you squint, you'll be amazed at how much simpler value identification is.

This skill is crucial to ensure your drawings are realistic, and equally useful in color mediums as well.

DEMONSTRATION

SHADE REALISTICALLY WITH GRAPHITE

Now it's time to move into shading the drawing you began with the two pears composition. You'll continue to use graphite pencils for this demonstration. Later, you'll explore the effects of shading with charcoal.

As you shade, squint at your subject often. Squinting helps specifically with simplifying values. And values are what this stage of drawing is all about.

I'd recommend using your hand mirror one more time before starting to shade and add details, just to check for errors in placement, proportion and perspective. Remember to face away from your image, capture both images in the glass and look into the mirror over your shoulder, glancing back and forth between both images.

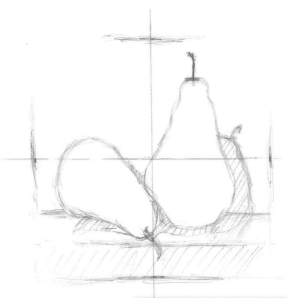

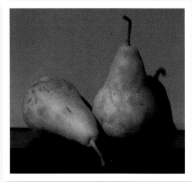

Your Finished Block-In

1 BEGIN SHADING

Now you'll start laying in some tone. Erase your axis and frame lines. Squint at your subject to reduce the image to blocks of value. Then use hatching to develop those shaded areas. A 2B is good for initial shading.

Once you get the initial tone for the positive spaces (the pears), lay in the background tone. Doing this fairly early will give you a frame of reference for judging the foreground values. Use loose, broad crosshatching to indicate the background. You can leave your hatch marks for a particular effect or you can use a tortillion to deepen and blend the background. You can see this on the right side of the drawing.

A broken graphite stick is great to lay in these large swaths of tone without creating a lot of pencil strokes. As you start darkening some values, switch to a 4B or 6B. Lighter values can still be achieved with a 2B.

At this point, you're still not getting lost in detail. The pears have a lot of tiny details and imperfections (bruising, dimples, etc.) that won't be indicated yet.

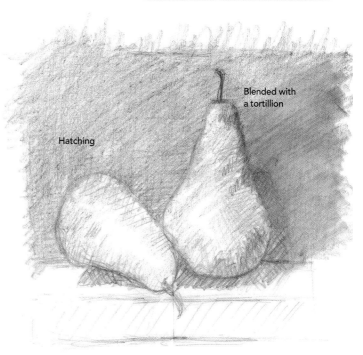

Hatching

Blended with a tortillion

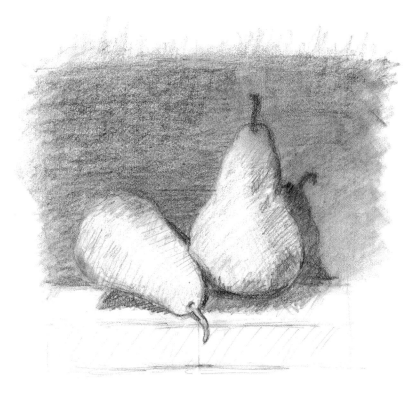

2 LOSE SOME LINES

As you darken the background to a more accurate tone, squinting will show you where certain parts of the pear outline can be softened or lost completely. These places are where the value of the pear and the value of the background are the same or nearly so.

While some drawings feature outlining very strongly to a great effect, this particular demonstration illustrates how to shade as realistically as possible, and in many cases, your eye loses natural lines that exist in reality, but your brain makes up for them with ease. Well-executed lost-and-found lines can add sophistication, drama and interest to your work.

TIPS

In this composition, the far left outline of the pear on the left is very nearly the same value as the wall right behind it. So use your kneaded eraser to lift out these lines. Your electric eraser will be too precise and will lift out too much graphite. To keep from lifting out too broad an area of graphite, use a pinched tip of your kneaded eraser.

If you squint, you'll see the left side and the very top of the pear's narrow neck is closer to the value of the background (lost line). But the core shadow on the right side of the neck is much darker than the value of the background. This gives you a definite found line. Again, squint and use your value scale.

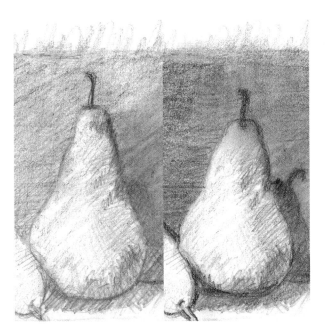

3 MAKE ADJUSTMENTS, IF NECESSARY

Although most of your placement, size and scale will be achieved in the block-in stage of your drawing, by glancing back and forth many times at frequent intervals during your entire drawing process, you will continue to make minor adjustments to your image. Blocking in your drawing takes care of the big issues that are really difficult (and sometimes impossible) to correct once you've begun shading. Any subsequent adjustments to placement or scale should be small enough to manage without marring your drawing.

Case in point: As I began shading my standing pear, I realized the pear was a little too tall and sitting too low, making the pear too long overall. But because these were minor adjustments, I was able to make them without leaving a ghost image or wrinkling or tearing my paper from too much erasing.

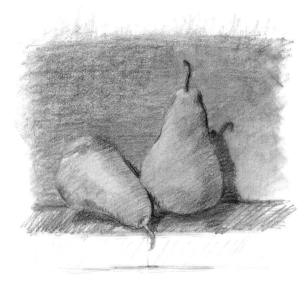

4 TONE IN THE PEARS

Lightly tone in both pears with light hatching marks. You can lift out the highlights with a kneaded eraser. Deepen the cast and core shadows. Don't be afraid to go dark with a 4B, 6B or 8B pencil. This particular composition has some dark tones to give you practice in shading darkly. Many developing artists keep their tones too light.

5 REFINE AND FINISH THE SHADING

Prop up your reference photo and drawing on an easel or drawing board, step away and use your hand mirror to check for any adjustments that need to be made. Graphite can only go so dark before leaving a sheen on your paper. This is where charcoal can be useful, as you'll see on the next page.

DEMONSTRATION

SHADE REALISTICALLY WITH CHARCOAL

Charcoal provides a satisfyingly intense value because it absorbs the light instead of reflecting it like graphite. I often combine graphite and charcoal in a drawing, but be mindful that once you have layered enough graphite to leave a sheen, charcoal won't adhere to your paper. Remember charcoal can be messy so if you're right-handed, work from left to right to avoid any smudging. If you're left-handed, work in the opposite direction.

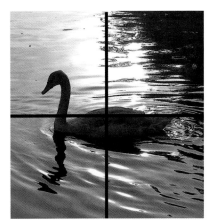

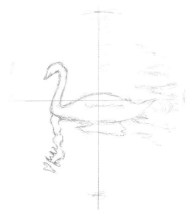

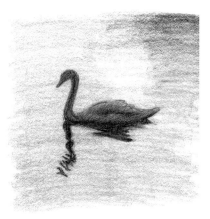

1 PREPARE YOUR REFERENCE PHOTO AND PAPER

Change your reference photo to gray-scale, if possible, and draw axis lines over your reference image and your paper. Mark some frame lines on your paper to indicate a square area. However, you may just want to work out from the center, as I usually do.

2 BLOCK IN YOUR MAIN SHAPES

With an H or HB graphite pencil, lightly sketch in the outline of the swan, blocks of shadow and the ripples. Compare both images and see how far the different parts of the image are from the axis lines and the edge of the image.

3 ADD TONE

Switching to a soft, chalky, charcoal pencil like a General's 2B-medium, hatch in the various dark values of the swan. The reflection of the swan is darker than the swan itself. Lay in an overall light tone for the background (Value 2 or 3). Go lightly from side to side with large arm movements to minimize banding. Render the upper-right corner slightly darker than the rest of the water.

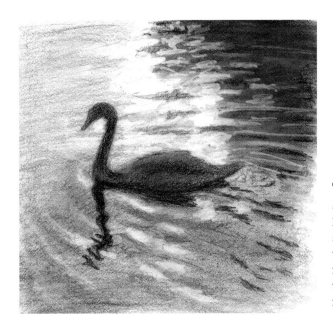

4 REFINE THE SHADING

Squint or use your value scale to darken the various areas of water. Use an electric or kneaded eraser to lift out the highlights of the ripples around the swan's neck. Then use a sharpened charcoal pencil to define the dark ripples around the swan's tail. Alternate erasures and charcoal pencil marks from the swan's back to the top of the image, this will indicate the sun's sharp reflection. Have fun with the ripples—water is fun to draw!

4 UNDERSTANDING RELATIVE PROPORTIONS

This chapter focuses on a principle that, along with values, professional artists use constantly in their art. Understanding relative proportions really separates the "men from the boys" in the field of art.

Relative proportions is just another way of saying you're comparing sizes and distances in your composition. When you're attempting to commit a shape to your paper, you're constantly judging proportions, asking questions like: "Okay, this object is a little bigger than that one, but how much bigger?"

Many times if you don't understand how to gauge relative proportions in a simple and reliable manner, you will end up sketching and erasing many times trying to get it to look right. There are going to be plenty of erasures in any drawing, so let's make it a little easier for you.

My claim that you can draw *anything* you see after practicing the concepts in this book is rooted first in a proper block-in and then in measuring distances and accurately gauging proportions to get the proper scale, size and dimensions of your drawing. The demonstrations in this chapter may seem mechanical and analytical, but artists use this method all the time, often unconsciously. While it may seem laborious, it won't take long before you begin to do this visually, without even thinking about it.

IN THIS CHAPTER

- Gauge Relative Proportions
- Negative Space as a Proportion

San Juan Capistrano
Graphite and charcoal on paper
11" × 8½" (28cm × 22cm)

Explore extra bonus features by visiting **artistsnetwork.com/drawing-secrets-revealed-basics**.

47

GAUGE RELATIVE PROPORTIONS

You can use relative proportions in a very analytical way by marking all your measurements before you draw, but a simpler way is by doing a block-in first and then using relative proportions to check and refine the image. I briefly touched on relative proportions in the first chapter on supplies when I suggested you purchase a sewing gauge. You can also use your pencil or a ruler as a makeshift sewing gauge. You can even use your thumb.

GAUGING PROPORTIONS

When you see an artist with one arm stretched out holding up a pencil and looking over the top, then rotating the pencil horizontally, they are gauging relative proportions, that is, the distances between various points in the subject.

Say a vase's height is a little longer than its width. The artist will measure the width and use it to gauge the height. By doing this, the artist may determine that the height is twice the width. The artist will then use this measurement to compare the relative sizes and distances of the other objects in their composition and transfer those proportions onto their paper.

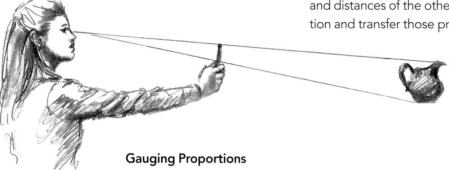

Gauging Proportions

SECRETS FOR GETTING ACCURATE MEASUREMENTS EVERY TIME

There are certain tips to remember whenever you are taking measurements and applying them to other distances in your composition. Here are three secrets that will enable you to get accurate dimensions and build them into more complex measurements.

SECRET #1 STAY IN THE SAME POSITION

It is essential that you stand or sit in the same place when you're determining all of the proportions throughout your drawing. Here you can see how my measurement changes as I move my sewing gauge nearer to the coffee mug. In each subsequent picture, the sewing gauge marker seems to get more and more inaccurate. That proportion is changing because my position is changing. This is why it is so important to take all of your proportion measurements from the same location. Even changing your vantage point (standing or sitting down) will change some proportions as well.

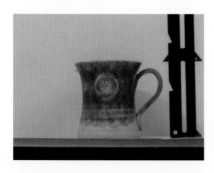

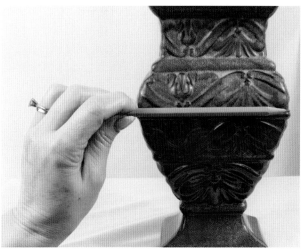

1 GET THE INITIAL MEASUREMENT

To determine the width of the vase, hold your pencil horizontally, lock your arm out straight and peer through one eye. Look at the pencil and the vase you are measuring. Make a note of that measurement by keeping your thumb there because that is the measurement you will use to gauge subsequent measurements. If you're using a sewing gauge then use the guide to lock your measurement.

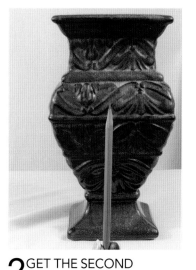

2 GET THE SECOND MEASUREMENT

To gauge the height, hold the pencil eraser-side down. Keep your thumb in the same position it was in when you marked your first proportion. Position your thumb at the bottom of the vase. In other words, you are using the same measurement to figure out both the width and the height. As you can see, the height of the vase is almost twice the width.

SECRET #2

This change in proportion also happens even if you are standing or sitting in the same place but your arm is not locked at all times, especially when you're measuring something from a distance. Try it sometime: Hold your arm straight out, elbow locked, and measure any given proportion. Then bend your arm a bit as you'll be tempted to do when your arm gets tired, and you'll see the proportion has changed.

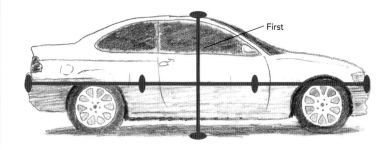

First

SECRET #3

It is easier to use a small measurement as your initial measurement because you can always build to a larger measurement. It's more difficult to cut a large measurement down to fit a small span. So if you have a tall composition, the width of the base of the object is a good start. But if you are drawing something long and horizontal, using the height is more helpful.

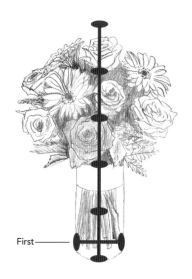

First

DRAWING A SINGLE OBJECT

This candleholder will require both vertical and horizontal measurements to achieve all the proportions, so you may want to use a sewing gauge to maintain your measurements until you change them and to help you see the actual measurements in terms of inches or centimeters.

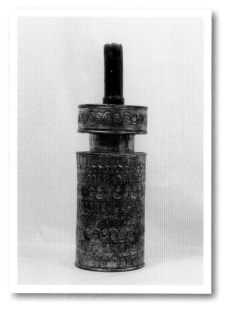

1 BLOCK IN THE SHAPES OF YOUR CANDLEHOLDER

With an HB pencil, mark your top and bottom frame lines, your midpoint and a vertical axis line. The midpoint will be the first base measurement you use to help you block in. Correspond the midpoints of the candleholder and your paper as you block in. Since this object is symmetrical, make sure your distances to either side of the axis line are equal all the way up the candleholder.

Various sets of proportions can help you refine your dimensions. Apply each of these sets to your block-in, erasing and refining as you go along.

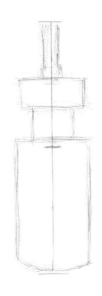

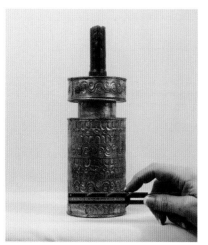
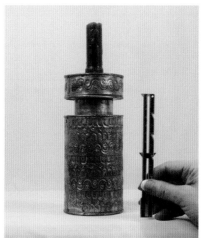
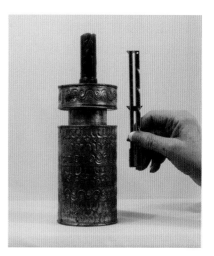

2 GAUGE YOUR FIRST SET OF PROPORTIONS

Figure out the width with your pencil or sewing gauge and then apply that measurement to the height, which is about 3$\frac{1}{3}$ widths. Make sure you are measuring from the bottom center of the candleholder base. Since this is a cylinder and the vantage point is a little higher than the table, you can see the curve of the cylinder.

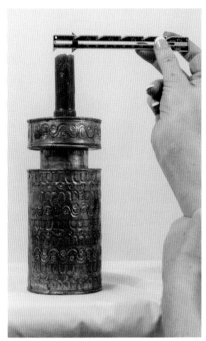

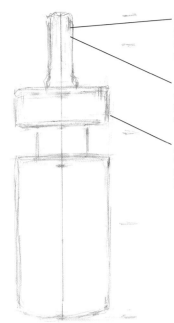

In this block-in, you can see the narrow neck is too tall, and when you glance back and forth, you can see the reason: the candle is too short.

Also when you check the candle width carefully against the reference image, you'll find the candle is drawn too narrow, which would affect its width measurement.

Another adjustment you may notice is that the upper neck of the candle holder is too narrow as well, so widen it to match the base.

3 GAUGE YOUR SECOND SET OF PROPORTIONS

Use the width of the candle to gauge the height of the narrower neck of the candle holder.

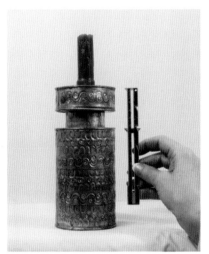

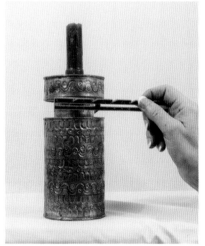

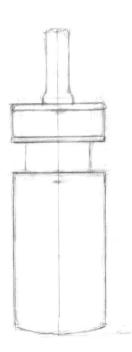

4 GAUGE YOUR THIRD SET OF PROPORTIONS

If you combine the height of the narrower neck with the height of the upper section of the candleholder, it happens to equal the width of the narrower neck. It would be harder to gauge this using the width of the candle because the neck is more than two widths but less than three. You'll notice the width of that neck is drawn too narrow in the initial block-in. With each subsequent set of proportions you gauge, you'll have more adjustments to make. These relative proportions enable you to get a very precise block-in before you begin to shade.

DEMONSTRATION
DRAWING MULTIPLE OBJECTS

When drawing single-object compositions, you can draw a block-in first and then use relative proportions to check and correct it. When drawing multiple objects in a composition, you may need to use relative proportions from the start to get an initial block-in.

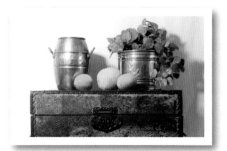

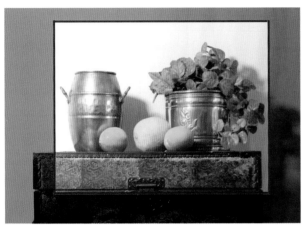

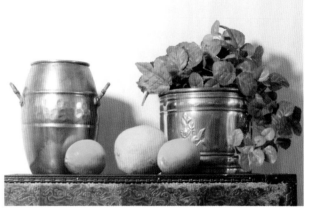

1 CROP YOUR COMPOSITION
Looking at the original photograph, at the top of the page, the focal point of the still-life composition is lost in a lot of surrounding space. It's sometimes a good idea to fill your paper with your subject, so crop some of that unnecessary space. This will make a more pleasing composition.

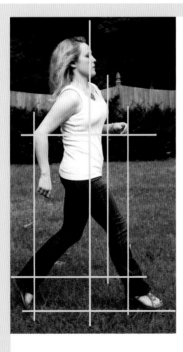

USE PLUMB LINES TO GAUGE PROPORTIONS

Plumb lines are imaginary straight lines that line up two or more points in a composition. They give you a visual reference point to plot the elements of your composition, and help you to gauge proportions in any genre (landscape, figurative, still life, portrait).

You can see several vertical and horizontal plumb lines in this photograph of a runner lining up different parts of her body so you know where to draw those parts in relation to each other. You'll be using plumb lines throughout this demonstration.

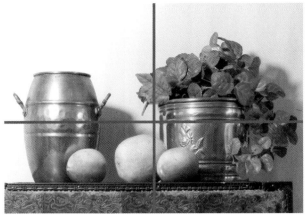

2 DRAW YOUR AXIS LINES

I've changed the reference photograph to grayscale and drawn axis lines on it. With an H pencil, lightly draw axis lines on an 8½" × 11" (22cm × 28cm) paper. The composition is cropped to fit your paper borders, so drawing frame lines isn't necessary.

TIPS

Remember, you can also lay your picture plane down over your reference photograph if you don't want to mark it. When using a picture plane to view a live, three-dimensional composition, make sure you hold it up in exactly the same place so the axis lines and center point align each time you look through it.

3 ANALYZE YOUR COMPOSITION

I've identified distinct sets of proportions to make it easier for you to understand them; they are specific to this composition. But keep in mind drawing is a trial and error where some measurements don't correspond with any subsequent measurements.

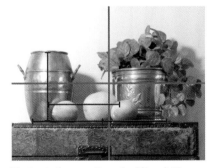

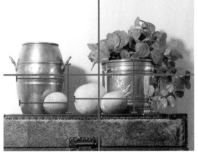

First set of proportions (red lines): The height of the copper pot will help you get the following distances:
- from the middle of the copper pot to the right end of the orange
- from the left side of the copper pot base to the middle of the orange
- from the middle of the orange to the right side of the brass vase

Second set of proportions (blue lines): The width of the copper pot will help you get the following distances:
- from the left edge of the copper pot to the right end of the first lime
- from the top of the copper pot shadow down to the chest
- from the left end of the orange to about the right end of the second lime
- the height of the brass vase

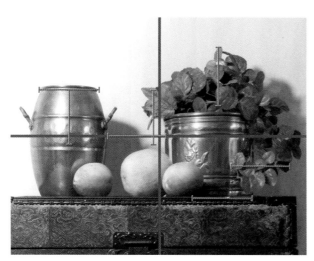 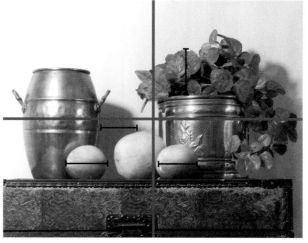

Third set of proportions (pink lines): The width of the top of the copper pot will help you get the following distances:

- the distance between the copper pot and the brass vase
- the distance from the top of the copper pot to the lower ring around the copper pot
- the distance from the top of the orange to the top of the very left part of the plant
- the distance from just inside the right end of the second lime to the right edge of the brass vase base
- the width of the lower part of the plant
- the distance from the top of the brass vase to the top of the plant

Fourth set of proportions (black lines): The width of the first lime will help you get the following distances:

- the distance from the copper pot to the middle of the orange
- the width of the second lime
- the distance from the top of the brass vase to the top of the left side of the plant

When working from life instead of from a photograph, don't forget to keep your arm locked every time you take a measurement, and make sure you're standing or sitting in the exact same spot as well. Something as small as a bending elbow or a chair that got bumped can wreak havoc on your proportions! Always look through one eye when taking measurements, too.

TIPS

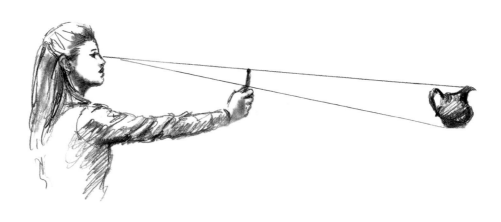

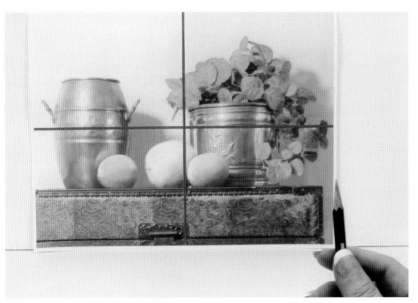

4 CREATE ADDITIONAL REFERENCE POINTS

Although your axis lines will be your main reference points, use relative proportions to indicate halfway points in each quadrant, making light marks on the page. This gives you four more center points that can help you orient parts of objects inside the four main quadrants.

Also, you can see the entire bottom half of the photograph can be pretty evenly subdivided by the top of the chest on which all the objects sit. Draw a light horizontal line across the bottom two quadrants to indicate the top of the chest.

You can see the little round highlights on the copper pot fall halfway between the vertical axis line and the left edge of the paper, forming a new midpoint.

The long, rectangular highlight of the brass vase accomplishes the same kind of midpoint on the right half of the paper. From there, you can block in a very general outline of both objects.

5 PLOT CONVENIENT REFERENCE POINTS IN YOUR OBJECTS

Working out from the center is a good way to start because it requires you to use your axis lines as reference points throughout your block-in. So sketch in just a few lines of the objects in the middle of the composition.

As you begin plotting the objects, find where those objects (including elements of lighting) cross various midpoints. A highlight can provide a great reference point for a whole object's proportions, as can the shape of a shadow.

6 BLOCK IN THE COPPER POT, THE FIRST LIME AND THE ORANGE

As you progress through any composition, you'll notice different measurements that jump out at you. Here are a few you might notice at this point in your block-in.

It helps to subdivide a symmetrical object into two equal halves. Drop a plumb line (red line) down the center of the copper pot, which also helps you line up the left end of the lime (purple line).

You'll notice that the top of the left lime falls halfway between the top of the chest and the horizontal axis line, giving you another relative proportion (green line).

To block in the orange's overall size and shape, go back to the copper pot's highlights you may have marked in step 5, which gave you the midpoint for the left half of the composition. If you use your pencil or sewing gauge, you'll notice the left end of the orange (blue line) falls halfway between that plumb line and the vertical axis line, subdividing the quadrant further. Block in the orange, being mindful where the top of it is in relation to the horizontal axis line. (Note the left end of the orange is also directly below the copper pot's handle.) Sketch lightly the shape of the copper pot's shadow.

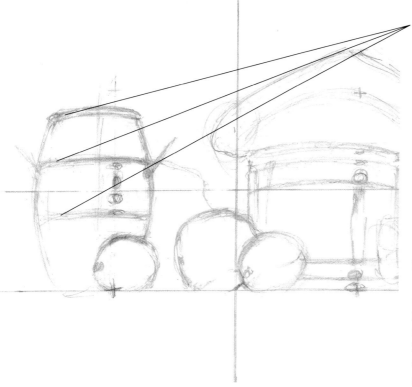

Refine the ellipses of the copper pot, observing carefully how the ellipse at the top of the copper pot is the most curved and each ellipse gradually becomes flatter and more horizontal as they lower to eye level. Remember Chapter 2 and what you learned about basic shapes: Ellipses at eye level are always more flat and horizontal; they curve more as they tilt away from the viewer's eye.

7 BLOCK IN THE PLANT AND REFINE THE COPPER POT'S PROPORTIONS

Block in the outer envelope of the plant (no detail yet). Always compare distances from various points of that shape to the axis lines and the border of the photograph.

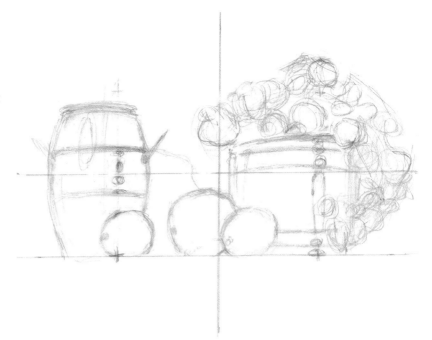

8 ADD IN A LITTLE DETAIL TO DEFINE THE PLANT

Now that you have lightly blocked in the outer silhouette, or envelope, of the plant on the right, it will be much easier to sketch in the individual leaves within that framework. Look back and forth from the photo to your drawing to make sure they are placed and sized correctly.

Continue to refine the shapes of the image using the same technique of looking back and forth or using the mirror technique described in Chapter 1 to compare your drawing and the reference photo.

9 LAY IN BLOCKS OF VALUE

If you have compared your sketch with the photo and are happy with the accuracy of the block-in, you can erase your axis lines and the outer envelope of the plant. At this point you are transitioning from a block-in to the shading portion of the drawing.

The grayscale reference photo really simplifies this complex composition, so squint to see the big blocks of value in the composition and lightly hatch in the cast shadows of the copper pot and brass vase. Do the same with the core shadows of the various fruits.

Wait to sketch in the value of the chest. Let that be last because your hand will smear it as you complete the top portion of the drawing.

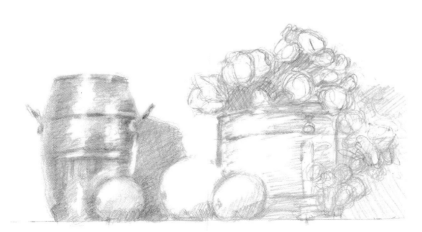

10 BEGIN REFINING YOUR SHADING

Switch to a 2B pencil. Squint constantly and use your value scale. See where you can lose some lines, e.g. the top of the orange and the bottom left of the copper pot. Tone the pot completely and then lift out the highlights with your kneaded eraser. The elements of lighting for the left lime are subtle because it has a textured surface, while the copper pot is metallic, bouncing off the light more brightly and distinctly. To bring out the lime's highlight, use your kneaded eraser to lift off the graphite rather than actively rubbing it out as you would for the copper pot's highlights.

11 CONTINUE

Refine the elements of lighting on all the fruit (refer to Draw a Spherical Shape in Chapter 2). Squint and use a 4B or 6B pencil to render your darkest darks on the right side of the pot and the right underside of the limes.

The highlights on the pot get wider as the pot gets wider, and the shading on the left side echoes the shape of the pot. Leave the plant values for the next step.

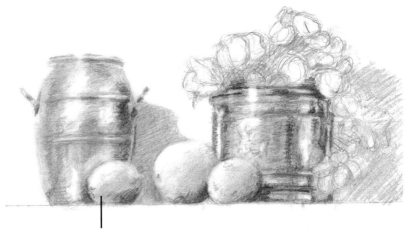

Since the surface the fruit is sitting on is rather dark, there won't be much reflected light shining up onto the bottom of the fruit.

Tone in all the leaves with a 2B pencil and light pencil pressure. Use relative proportions to get the general shape and size of the leaves. Define the visible main veins of the leaves by sketching a darker line down the middle of those leaves. Some are not so visible, so ignore them.

Deepen the shadows between the leaves with a 4B or 6B pencil to give depth and bring the leaves out from the background. Because the leaves incorporate so many different values, squinting throughout this process is key.

Lift out the highlights between the radiating veins of the leaves with an eraser.

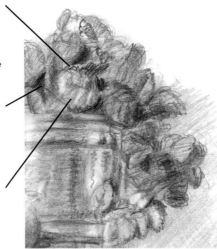

12 REFINE THE PLANT

Refining the plant will involve a balance between laying in value with your B pencils and lifting out highlights with your eraser.

Use a kneaded eraser molded into a tip to lift out highlights. These highlights bring the part of the chest just below the metal banding out toward the viewer, and more than any other feature on the chest they give a three-dimensional effect.

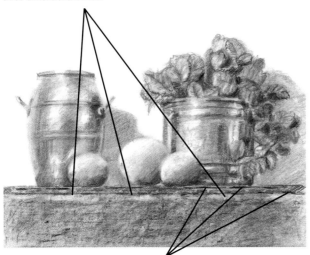

13 RENDER THE CHEST

For the chest, apply a textured rubbing over a wooden plank table, fine-grit sandpaper or even concrete. Use a ½" (1cm) graphite stick laid on its side. Lightly rub the graphite stick over the paper. Move the paper around to different spots to produce a layered effect (especially important with surfaces that have distinct pits or ridges, which can show up in graphite). I left the lock of the chest out of the final drawing because I felt it would bring the viewer's eye down, but that's up to you.

Copper Pot Composition
Graphite on paper
8½" × 11" (22cm × 28cm)

Line the very small, narrow edges at the top of the chest with a sharpened 6B pencil. Vary the distances between the dark lines and the lengths of those lines to lend more interest.

NEGATIVE SPACE AS A PROPORTION

The key to gauging relative proportions is a keen eye coupled with well-developed observation skills. A crowd of people can look at the same still life arrangement or landscape and produce a wide range of drawings—many that look somehow lopsided or off. The ones that look right are the ones that show the proper proportions and relative distances between the objects in the drawing.

Gauging the relative proportions of negative space, especially shadows and areas that are light-colored, can be challenging because it's so easy to assume negative space is just a dark wall behind the composition. I've discussed negative space in previous chapters, but let's talk about it specifically in the context of relative proportions with this photograph of a basic shapes arrangement.

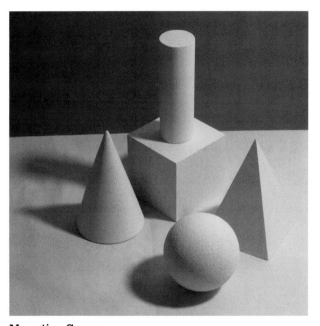

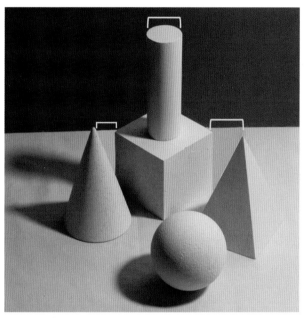

Negative Space

The black background is a negative space, but so is the white tablecloth between the shapes, despite its light color. (The shadows count as positive space since you block those in with the main objects.) Pay attention to the shapes this negative space makes. Remember that when you're not sure you have the shape of a positive space right (let's say the cube and the pyramid seem too close together), switch your focus to the negative shapes around it. Measuring the proportions of those spaces and the relative distances to one another, as well as the overall shape of them, can point out just where you have the positive shapes wrong.

Width of Negative Space

Here you can see the two triangles of the tablecloth on either side of the cube. You can see the width of the negative space on the right is about equal to the width of the cylinder, so you know to keep the pyramid about that distance away from the cube.

Try sketching this basic shapes arrangement, incorporating your elements of lighting from Chapter 2 with what you know of values from Chapter 3 and relative proportions from this chapter.

When you can begin transitioning back and forth smoothly and easily between analyzing the positive and negative spaces, you'll find it's so much easier to accurately gauge the proportions of very complex compositions.

5 DRAWING THE HUMAN FORM

Mastering figure drawing is an ongoing journey. You could study nothing but drawing the figure your entire life and still learn something new as you took your last breath. This genre is fascinating, especially as you discover new poses, subjects, materials and techniques to excite and inspire you. This chapter will give a solid foundation upon which to explore this area with confidence.

Before we get to the step-by-step demonstrations of the figure, you'll experiment with how to imbue your figures with energy and learn to structure them with accurate proportions. Understanding muscle structure, foreshortening and how to draw the figure in different positions rounds this chapter out, and you'll find by the end of the chapter, the concepts you've learned combined with the techniques you mastered from previous chapters will open your eyes to your own abilities.

One of the difficulties within figure drawing is that you can get so involved with formulas and guidelines in an effort to draw a "perfect" figure. You can easily lose the vitality, spontaneity and joy of a subject brimming with life. My purpose with this chapter and the book as a whole is to provide you with a basis for drawing the figure without tying you down to too many musts and must-nots. The point is not to get caught up in the measurements and formulas but to use them to help you see the figure.

IN THIS CHAPTER

- Gesture Drawing
- Body Proportions
- Using an Artist Mannequin
- Muscle Structure

The Shawl
Graphite and charcoal on paper
14" × 11" (36cm × 28cm)

GESTURE DRAWING

Gesture drawing, also known as action drawing, is the attempt to quickly lay down on paper a model's form and movement. The primary objective of an action or gesture drawing is to loosen you up to render the core movement of a figure. It almost acts as a block-in of sorts in that it trains your eye to start big before working small.

As these are timed exercises, there is no time for detail or line work; it's just a practice exercise to quickly describe the figure's action or direction with a few swipes of charcoal or graphite. In a longer drawing session it's easy to get caught up in the details and measurements of the figure and lose the initial raw impression of your subject, which should be the basis of your drawing. The measurements come later. Gesture drawing trains you to capture this raw impression so you can incorporate it into any finished figure drawing.

WHAT YOU NEED TO KNOW

- You can use either a pencil or vine charcoal with a gentle, overhand grip to keep your lines loose, light and sketchy.
- Newsprint is best because it's cheap and large and encourages you to work big.
- Set your timer for 2 minutes to quickly capture that visceral first impression of the model's pose. Any longer and you'll start getting distracted by detail.
- Use energetic, overlapping sketch lines to indicate the basic shapes of the figure. Rather than lifting your pencil off of the paper in choppy strokes, keep your pencil or charcoal on the paper to keep the lines flowing.
- Don't bother erasing anything; you're not aiming at perfect outlines. All those overlapping lines are gradually honing the shapes of the figure.

BALANCE YOUR FIGURES

Before I show you how to do a gesture drawing, keep in mind a few things that you'll need to know first. In order to maintain equilibrium within your drawing, you need to understand plumb lines. Plumb lines provide an easy way to balance your figure no matter what position it's in.

The plumb line drawn through the dancer in this painting shows you precisely why she is in balance even with a dramatically extended leg. The weight-bearing foot is directly in line beneath the body to support the weight of the body.

Balancing Figure

When drawing any figures that are maintaining their balance with their body weight on one leg, drop a very light plumb line from between the collarbones to the floor, which is where the weight-bearing foot should be (directly under the body) to look visually balanced.

Figures in Motion

However, when figures are in motion, such as football players racing for a touchdown, they are not trying to maintain their equilibrium. Their motion is entirely informed by their momentum, and plumb lines will not apply to them.

Contrapposto

When a standing person is putting her weight on one leg, it causes a domino effect: The pelvis drops on the resting side, which causes the rib cage to tilt in the opposite direction to maintain balance. The head then tends to tilt in opposition to the rib cage and the resting knee drops lower than the weight-bearing knee. This is contrapposto.

Most people will naturally fall into a contrapposto position when they're standing since it's a little more comfortable than standing at attention. Because of this, you would do well to get familiar with how to draw contrapposto positions.

DEMONSTRATION
GESTURE

You have a little more time with this type of gesture drawing but not much. Once you've trained yourself to see the truly basic core movement in a figure, you can develop it a bit further with a finer tool such as a pencil, vine charcoal or conté crayon, though you'll still use newsprint and your timer. You are still focusing on the main movement, but you can develop the limbs (including joints) with overlapping sketch lines and basic shapes. Because this is much like a quick block-in, this type of gesture drawing could be developed into a finished drawing.

Set your timer for 2 minutes. Use an overhand grip with your drawing medium. Begin your timer.

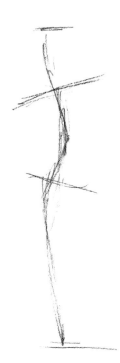

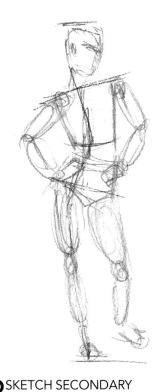

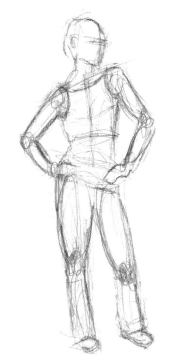

1 DRAFT THE CORE ACTION
With this figure, there is a definite weight-bearing leg, which will continue a single core line. Lightly indicate the head with just a continuation of that core line. Draft in the opposing shoulder and hip angles.

2 SKETCH SECONDARY MOVEMENTS
Use light lines to block in the basic shapes that suggest the remaining body parts (trapezoids for the chest and pelvis, ovals for the limbs, etc.). Drop a light plumb line to confirm your foot placement.

3 FILL OUT THE REST OF THE FIGURE
Show just enough detail to communicate the body parts such as a few features of the head, blocked-in hands and the shapes of the shoes.

TIPS

1. After you lay in the secondary movements, use mental plumb lines to orient and line up various parts of the figure.

2. Gesture drawing can work with still, quiet poses as well. But for great action poses, use athletic clothing catalogs.

FORESHORTENED GESTURE

This pose is a little more complicated because it isn't standing straight up and some body parts are foreshortened. Foreshortening refers to the visual effect (or optical illusion) that makes an object appear shorter than it actually is because it is angled toward or away from the viewer.

Sketching both the visible and hidden lines as though the figure was transparent will help you accurately gauge foreshortened body parts (like the leg in this pose). Doing this actually helps you gauge all the proportions in any gesture drawing (or full-figure drawing).

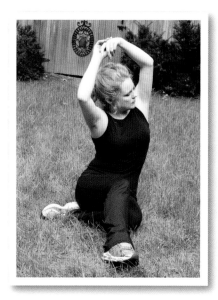

<div style="writing-mode: vertical">Gesture Drawing</div>

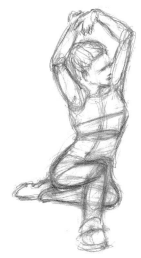

1 DRAFT THE CORE ACTION
Sketch the core line, then the shoulder and hip angles. The lines of the arms give you the top of the figure. Indicate both legs, even the hidden one.

2 SKETCH SECONDARY MOVEMENTS
Use light lines to block in the basic shapes that suggest the remaining body parts, including the folded leg. Don't draw the foreshortened leg too long.

3 FILL OUT THE FIGURE
Keeping your pencil going, darken the outlines of the figure and indicate some features. If you will develop it into a finished drawing, you are ready to begin erasing and refining unnecessary lines.

Extended Gesture Drawing
Mastering gesture drawing will benefit you beyond drawing the human form. Here you can see how it can help you capture the raw energy and spirit of different animals.

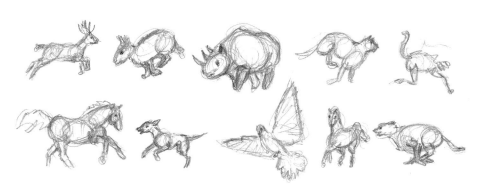

BODY PROPORTIONS

A convenient way to measure the human figure is to use the height of the human head. Most adults are seven to seven-and-a-half heads high although the classic division of the body is eight heads. Take the head measurement with your pencil or sewing gauge and simply drop that measurement all the way down the body.

Refine Your Skills

A good way to refine your observation skills is to look at pictures of all kinds of people in magazines or photographs, and to measure them by their head length. As you do this, you'll begin to get a feel for how to segment a person just by looking at them. But the head is only one of many different relative proportions you'll be measuring in a figure. The goal is to see like an artist, not to be a slave to a particular measurement. This basic division is just background knowledge.

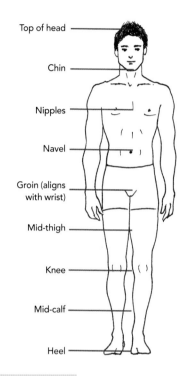
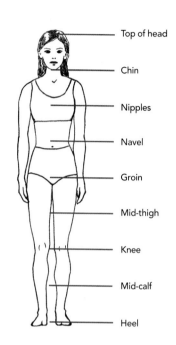

Top of head
Chin
Nipples
Navel
Groin (aligns with wrist)
Mid-thigh
Knee
Mid-calf
Heel

Top of head
Chin
Nipples
Navel
Groin
Mid-thigh
Knee
Mid-calf
Heel

TIPS

As a child grows into adulthood, the midline of their body shifts gradually from their navel to their groin.

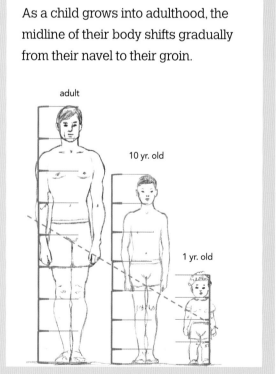

adult

10 yr. old

1 yr. old

Children's Proportions

When drawing a child, there are no set rules because children are all growing at different rates. But it's helpful to know that a child's head is larger in proportion to their body than in the case of adults. Here are examples of three different ages where you can clearly see the changing proportions. Children tend to be between four and six heads tall.

USING AN ARTIST MANNEQUIN

A wooden artist mannequin, which can be purchased at many art stores, will help you understand better how mobile and dynamic the trunk (chest and hip area) is and how the head, arms and legs respond as the trunk turns and bends. They may seem simplistic to work from, but their body formation and joints are similar to humans and they provide good learning opportunities to help students begin to understand the human figure. They also help artists study the foreshortened view of arms, legs, head and trunk—which can be tricky.

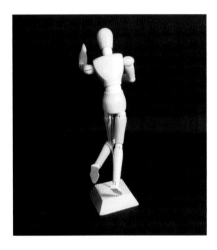 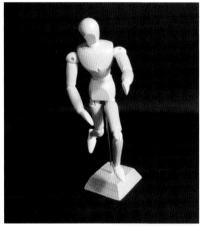 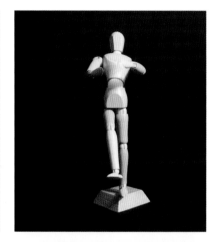

Keep in Mind

1. Mannequins are usually shorter than actual humans, perhaps six to seven heads, but the divisions are not the main focus as much as the action of the figure and the rendering of the shapes, foreshortening and shading.

2. Block in your mannequin with the core lines and basic shapes as you did with the gesture drawings before deciding if you want to develop detail in your sketch.

3. Throughout this book, I say you must draw what you *see*, not what you *know*. This applies especially to foreshortening. Foreshortened body parts look so much shorter than you know they must be. For example, in this picture, the right thigh looks much shorter than the right arm, even though you know in reality this is impossible. To compensate you'll be tempted to draw a foreshortened limb longer than it actually looks in the image. But when you finish, the limbs will be asymmetrical. Force yourself to use other markers. In this example, notice how the mannequin's left hand and foot appear to be the same size since the hand is so much closer to the viewer than the foot, and how the right thigh is about the same length as the right hand.

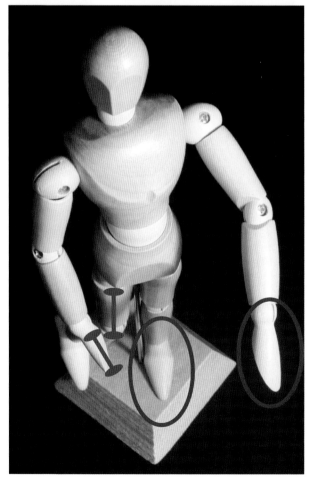

USE WHAT YOU LEARNED

Use what you learned in the gesture drawing lesson to develop a sketch of the artist mannequin sketches shown here. Identify the core action and then build the body parts from it with basic shapes.

Images like these help the artist see how important the mannequin is in understanding movement and how the light falls on the planes of the body. Tracing the mannequin and the finished figure can help you understand how the muscles and skin work together.

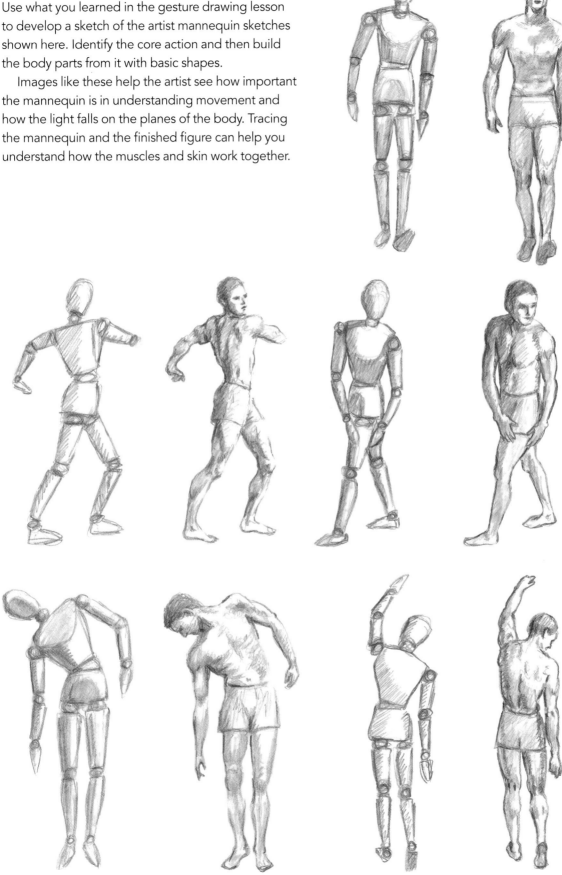

MUSCLE STRUCTURE

If figure drawing is of special interest to you, I encourage you to observe human anatomy from life or from photographs and see how the skin lays over the skeleton and muscles in their different positions. Here is a basic diagram of the main muscle groups on the human form. Of course, these muscles will most likely be more clearly delineated on the male physique than on the female.

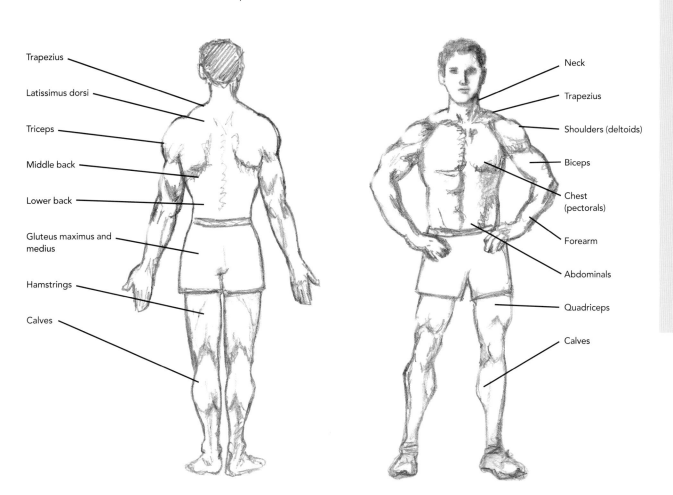

Trapezius

Latissimus dorsi

Triceps

Middle back

Lower back

Gluteus maximus and medius

Hamstrings

Calves

Neck

Trapezius

Shoulders (deltoids)

Biceps

Chest (pectorals)

Forearm

Abdominals

Quadriceps

Calves

Observing Athletes

A wonderful way to observe muscle play under the skin is to watch athletes in various sports. If their uniform doesn't cover too much of their body, you can get a clear vision of the give-and-take of muscles in different body positions. The Olympics are a terrific opportunity to refine your observation skills in figure drawing.

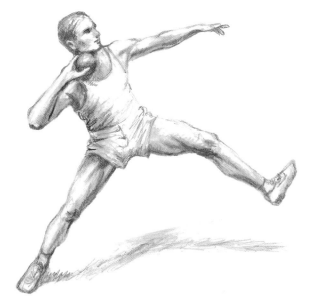

DEMONSTRATION
DRAWING A CHILD

This lesson is where so many of the concepts you've learned so far come together: block-in, values, gesture drawing, body proportions and relative proportions. There are so many avenues you can choose in relation to figure drawing. You can people your landscapes or cityscapes. You can draw children as they grow up. You can explore fashion illustration or animation. I'll demonstrate a full figure drawing with a great action pose of a child playing baseball.

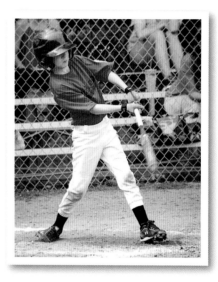

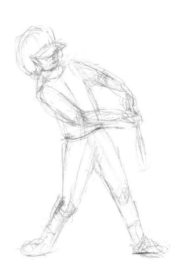

1 DRAFT THE CORE ACTION
Sketch in axis and frame lines if you need them. Use a HB pencil with a light overhand grip. Pay attention to the arching core line and the drastic difference between the shoulder and hip angles. Go ahead and draft the line of the baseball bat itself since that counts as part of the figure and thus part of the movement.

2 BLOCK IN THE FIGURE
Build the gesture of the figure by lightly sketching basic shapes for the body parts. Glance back and forth many times to ensure you have each body part, as well as the body as a whole, correctly placed and sized.

3 CLEAN UP YOUR BLOCK-IN
Erase your core action lines. Refine the contours of the arms and legs by erasing the hidden lines of the joints. Sketch in the hands gripping the bat as well as a few basic facial features visible beneath the helmet visor.

4 FINISH THE BLOCK-IN; ADD SOME DETAILS

Add more detail to the shoes and lightly shade in the side plane of the helmet. Clean up the facial features. Develop the hands and the shape of the bat. Begin to lay in some drapery lines on the shirt and pants to show the fabric pulling over the twisting body frame, but don't overdo those drapery lines.

5 BEGIN TO LAY IN INITIAL VALUES

The light is directly overhead but it's diffused so that the shadows aren't strong. Lightly hatch the cheek and neck with a 2B pencil. The focus is on the face, so the farther away the details from the face, the less defined they should be (less contrast, fewer lines, etc.).

6 BEGIN REFINING YOUR VALUES

Deepen the values of the clothing and clean up the outlines of the shoes and the arms. Lay in the core shadows of the undersides of the arms. Lose some lines where the highlight is hitting the fabric, such as the folds on the hips. Hatch in some lines to delineate the cuffs of the pants and across the bat to show motion.

7 CONTINUE REFINING YOUR VALUES

Deepen the value of the shirt. Blend a darker value for the lighter area of the helmet, and pull out some highlights to communicate the shiny surfaces of the helmet and the rim of the visor. Clean up the outline of the whole figure and blend in the gray gloves. Darken the black socks and shoes, and deepen the value of the knees where the dirt is.

8 ADD FINISHING TOUCHES

Lost lines aren't the only element of line variation. Emphasize some of your found lines with a 6B pencil, such as part of the outline of the hip folds, the inside of the knee, the shirt collar or the left sleeve. Add in the cast shadow on the ground lightly with the side of the pencil. Add the band to the bat, but you may blur the edges of the bat to reinforce its action.

DEMONSTRATION
DRAWING A WOMAN

Let's explore color with our next demonstration. Color is a multifaceted discipline and takes years to master, so a good way to start this exploration is with a limited palette, which is simply a painting or drawing that has just a few colors. A limited palette not only can be beautiful in its simplicity, but it also helps beginning artists remember that one of the most important aspects of art is accurate values—even more than color. Values are easier to recognize if there are just a few colors. Tinted charcoal pencils or Conté crayons are a wonderful tool for an artist delving into color.

MATERIALS LIST

General's charcoal pencil in black
 (557-HB hard)
Derwent charcoal pencil
 (Chocolate 6600)
General's Pastel Chalk pencil
 (4429 Sanguine)
General's Pastel Chalk pencil
 (4451 Van Dyke Brown)
General's Pastel Chalk pencil
 (4441 Gold)
Conté crayons in black, brown, sanguine
 and white

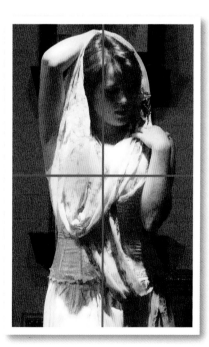

1 PREPARE YOUR PAPER
For this drawing, a medium-toned paper provides the basic skin tone for your subject. Draw your axis lines with an HB pencil. If you want to frame the finished drawing, keep in mind that the frame will overlap the outside edge of your paper, so mark your frame lines just inside. For this drawing, the figure goes all the way to the bottom of the paper, so it's okay for a mat and frame to cut off a bit of that.

2 BLOCK IN THE FIGURE
Use your axis lines as your main reference points as you block in the general form of the girl. Use basic shapes as needed, such as cylinders for the arms and an oval for the face. Use your mirror technique to check your proportions and placement before moving on to the next step—glancing back and forth many times. Don't rush any step of the block-in! It's the foundation of your whole drawing.

3 BUILD UP YOUR BLOCK-IN

Now you can sketch some additional elements such as the facial features and some main drapery folds. Notice for the facial features, I drew curving lines for the eyes, nose and mouth to indicate the downward tilt of the head. Again, refrain from drawing detail, and glance back and forth to check your placement before moving on to the next stage.

4 HATCH IN YOUR BLOCKS OF VALUE

Once you've confirmed your placement, erase those curving lines on the face, leaving simple marks to indicate the features. Note the direction of the light; squint and lightly hatch in the large blocks of value across the whole figure. Hatch the darker blocks of value more heavily.

5 BLOCK IN THE FACIAL FEATURES

Develop the facial features a little more, keeping in mind that most of the detailed rendering of the face will be accomplished with values and color, so don't get too caught up in line work. Sketch in a few more folds in the scarf. Once you've confirmed the placement of all the elements of the drawing against the reference image, erase your axis lines.

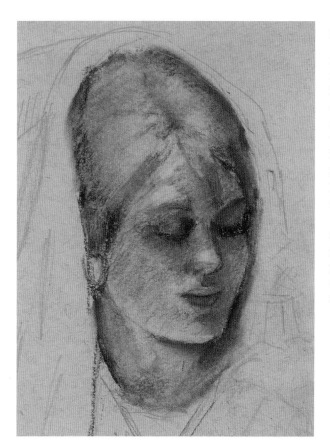

6 DEVELOP THE HEAD

The light is coming from the upper left, which casts diagonal shadows down across the face. Lightly tone in the hair and face with the brown Conté crayon, keeping your pressure the lightest where the light is directly hitting these areas. Define the edges of the hair with a darker tone using the black and the sanguine Contés. Lift out the highlights on the forehead and the tip of the nose with an eraser. With medium pressure on your black Conté, tone in the scarf just beside the shadowed cheekbone and jaw to create a background value for the face. Use the brown Conté to define the chin, losing the line where the values of the cheek and neck are closest.

Use your value scale to compare the shadow areas of the neck. Carefully shade the darker areas of the face with light pencil pressure, alternating between the brown and sanguine pencils. Use your black charcoal pencil to further define the eyes, nose and parting of the lips. Your red Conté crayon can indicate the ear and lower lip.

Muscle Structure

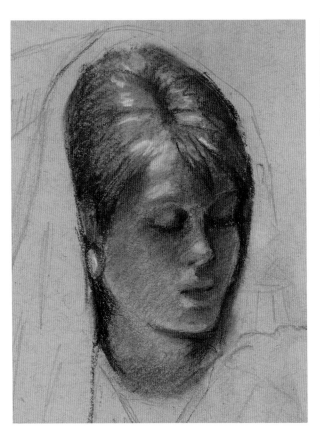

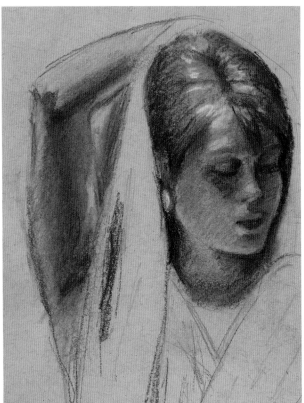

7 DEVELOP THE HEAD FURTHER

Darken the edges of the hair with the brown and black Contés and make sure to define the part in the hair and a few streaks with the brown. Use the black to give definition to the bangs. Use the sanguine chalk pencil to bridge the gap between the highlights at the top of the hair and the dark brown Conté crayon along the edge. The white Conté will provide a few quick highlights without overdoing it.

Because the light is high overhead, the forehead and temple need to be darkened with the brown and sanguine Conté. Use your black Conté to define the deep shadow under the earring as the neck curves back under the scarf, and develop the shadow around the face. Match the tone of the highlighted cheek with the photo. Check the shapes and positions of the nose and mouth; alter as needed.

8 DEVELOP THE UPPER ARM

Shade the arm as you would a cylinder; the elements of lighting are identifiable. The toned paper will serve as the highlights and reflected light. Use your brown Conté across the core shadow and midtone areas of the bicep, then reinforce the core shadow with the sanguine Conté, which will also give definition to the elbow bone. Add depth to the midtone.

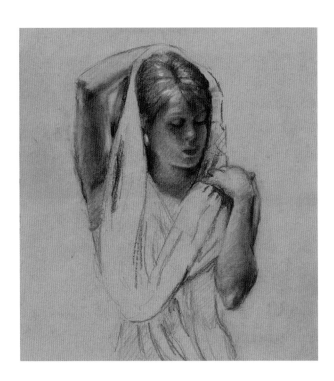

9 DEVELOP THE LOWER ARM

Build up the elements of lighting on the lower arm, leaving the back of the hand alone since the toned paper will serve as that highlighted area. With the black Conté, vary your line width as you define the arm. Variable line width in your drawings will add interest and sophistication like lost and found lines do. With your General's Pastel Chalk pencil (4441 Gold) deepen the skin tone where appropriate, such as the underarm, the jaw, the outline of the fingers of the lower arm and the midtone of the lower elbow.

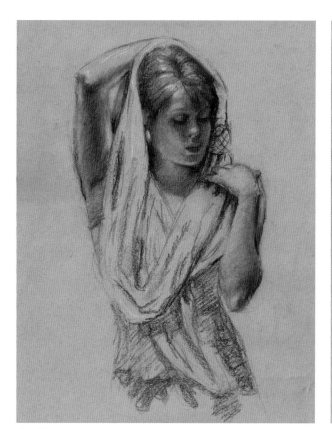

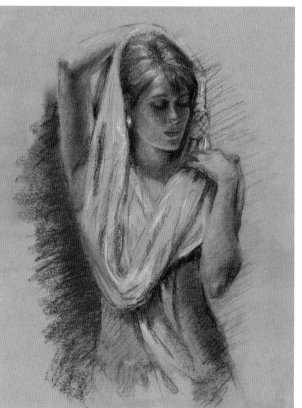

10 DEVELOP THE FABRIC FOLDS

With your sanguine Conté crayon, lay a midtone over the initial hatched-in blocks of value you added in step 4. Lay in a few sanguine lines for the scarf folds. One thing to keep in mind when you are drawing fabric folds is how thick or stiff the fabric is; in this case, the scarf is a little stiff, so where it bends by her ribs, it creates more angled lines. Your black and brown pencils will help communicate this.

11 FINISH THE FABRIC AND ADD THE BACK-GROUND

Darken the darkest shadows (the cast shadow from the lower arm and the cast shadow just below the scarf around the waist). Use the white Conté to lay in long, thin chunks of highlight echoing the curve of the scarf around the head. With your tortillion, blend in the sanguine shadow at her waist; leave the black Conté a little less blended for interest.

Many background treatments would complement this figure but I recommend simplicity to keep the focal point on the head. All you need to do is take your brown or sanguine Conté, break off a small piece and lay it on its side, and shade roughly to ground the figure. Add a few hatch marks along the right side with the black Conté. You may apply a few more finishing touches, such as blending the shadows of the skirt or losing the line of the top of the arm draped over her head.

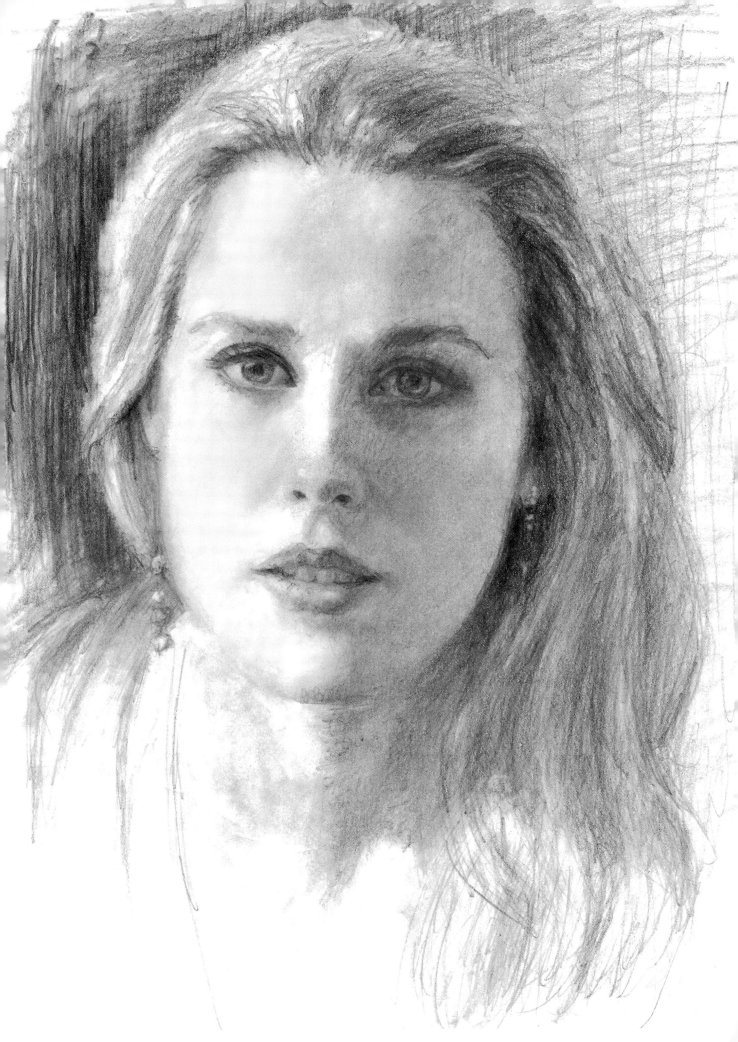

6 DRAWING THE HUMAN HEAD

It is said that if you can draw or paint a likeness in a portrait, you can draw anything. Perhaps that is because through years of practice the portrait artist has managed to seamlessly integrate all of the concepts I cover in this book, such as understanding basic shapes, elements of lighting and values, blocking in correctly and gauging relative proportions. Portrait artists have refined their ability to really see and judge distances down to minute details. They understand how rendering correct values is absolutely critical to getting a likeness. The experienced artist's eye has been trained to pick up every detail in every part of the face, and every feature is examined and rendered according to its unique shape. Their brain is firing on all cylinders when they are drawing or painting.

When you are drawing or painting a face, you will want to study the overall shape of the face, as well as each feature, before beginning your drawing. The face is a wondrous thing, something to appreciate in its uniqueness. The artist who can capture the essence and personality of the sitter in a portrait is a true master.

IN THIS CHAPTER

- Proportions of the Human Head
- Facial Proportions From Different Angles
- Planes of the Head
- Squint for Face Values
- Draw Facial Features

Sincerity
Graphite on paper
11" × 8½" (28cm × 22cm)

PROPORTIONS OF THE HUMAN HEAD

FRONT VIEW

If you have ever looked at beautiful portraits and wondered how professional artists can paint such good likenesses, here's one secret they understand: There are guidelines that nearly every face follows.

You may not be that experienced yet, but you can begin to draw faces by learning some general rules to help you understand the proportions of the human face. These guidelines will be the norm, but you will want to examine each face individually for the slight variations it will inevitably have that make each person's face unique. Then you can tweak your drawing accordingly to represent those changes.

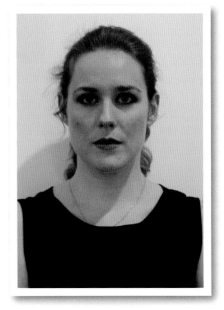

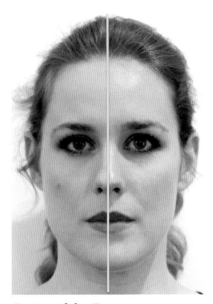

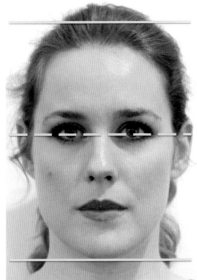

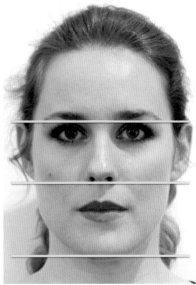

Center of the Face
A vertical axis line goes down the center of the face.

Eyes
The eyes, specifically the tear ducts, are generally halfway between the top of the skull (not the hair) and the chin.

Nostrils
The bottom of the nostrils is about halfway between the start of the eyebrows and the chin.

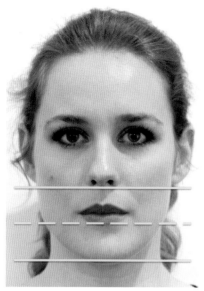

Lower Lip
The bottom of the lower lip is halfway between the nose and the chin.

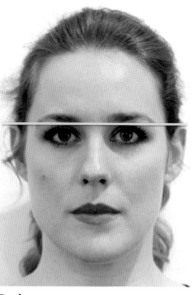

Eyebrows
The tops of the ears tend to be in line with the start of the eyebrows.

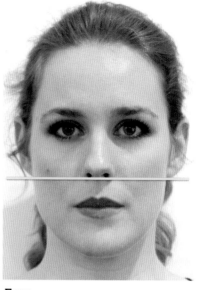

Ears
The bottoms of the ears are usually in line with the bottoms of the nostrils.

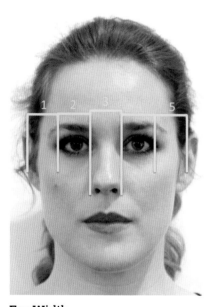

Eye Width
A typical face is generally five eye-widths wide with an eye width between the eyes, and from the outer corners of the eyes to the sides of the skull.

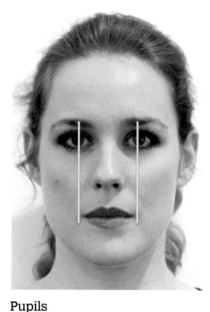

Pupils
The pupils of the eyes will either be directly above or just outside the corners of the mouth.

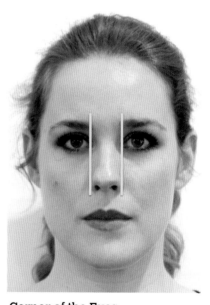

Corner of the Eyes
The inside corners of the eyes often line up with the outer sides of the nostrils.

TIPS

Using these rules you should be able to position the facial features correctly. But always keep in mind that these measurements and positions are idealized! In reality they will differ slightly. That is what makes up the uniqueness of a human face.

SIDE VIEW

The frontal facial proportions aren't the only ones you need to be aware of when drawing the human head. There are certain guidelines to follow in profile views as well. Also, when you compare a man's head to a woman's head, you'll notice subtle differences. Women's faces generally have softer lines and shadows; men's faces have sharper angles with more protruding brow bones and chins, and often stronger noses.

Several of the guidelines of the frontal view remain visible in the profile view. You will soon learn these measurements and apply them instinctively to your portrait work. In the following diagrams, the red lines indicate the vertical and horizontal lines dividing the head into four equal quadrants.

The pupils line up just outside the corners of the mouth, same as in the frontal view.

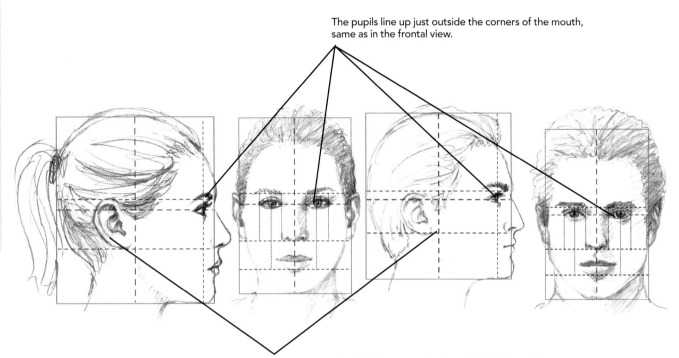

The ear sits just behind the center (red) vertical axis line in the lower quadrant. Most artists don't set the ear back far enough.

A Child's Face

As you may recall from the previous chapter, the younger the child, the larger the head will be in proportion to the rest of its body.

Unlike on an adult's skull where the eyes are the midpoint between the top of the skull and the chin, on a child's skull the eyebrows are the midpoint and the ears are just below that line. The eyes are large for the face, and there is a bit more than the width of an eye between them. The bridge of the nose has a concave shape, usually significantly more than an adult's bridge, and the upper lip protrudes a bit beyond the lower lip.

FACIAL PROPORTIONS FROM DIFFERENT ANGLES

With an understanding of the basic facial proportion guidelines for frontal and profile views, you're ready to focus on how dramatically the shapes of those features change with the head at different angles.

You really have to hone your artist's eye to observe the subtle differences that communicate a particular angle. The slightest angle change will require adjustments across the entire face and head.

HEAD TILTED DOWN

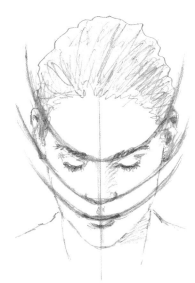

Looking Down

The brow line starts between the brows and angles up to the ears like a loose V so that the ears appear higher than the brows. Even a slight upward or downward tilt of the head will change the placement of the ears. But the lines of the mouth and nose remain parallel with the eyes and eyebrows no matter what direction the face tilts in.

Observe the shape of the ears from a front view; they appear flattened whether the head is tilted up or down or looking straight on. At a downward angle, the tip of the nose lowers, and the opening of the nostrils is hidden. The line of the mouth may curve up slightly at the ends, and you see more hair on the scalp.

HEAD TILTED UP

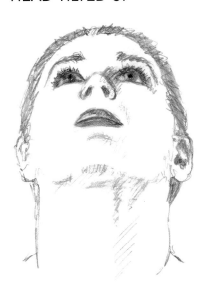
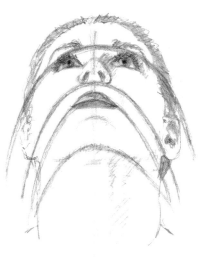

Looking Up

The brow line starts to curve downward from the point between the eyes all the way to the ears, which now appear lower than the brows, almost at chin level.

The tip of the nose at this angle is at eye level and the nostrils are prominently seen. Note the downward slant of the mouth. There is just a rim of hair seen at the forehead and around the face, and it extends a little below the ear.

Observe the neck as the skull is tilted back and see how the throat flares out as it sits on the shoulders.

HEAD AT THREE-QUARTER VIEWS

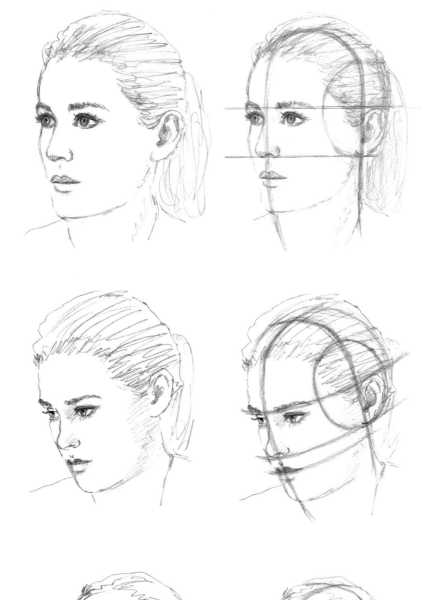

Basic View

The side of the skull is a rather flat plane, so observe how the two axis lines cross over the top of the skull then drop straight down on the sides. Note how the shapes of the ears, eyes, nose, mouth, chin and forehead have changed from the previous views.

Tilted Down

This is a down-tilted three-quarter view. You can see in the sketch on the right that the side of the skull is rather flat (see the circle), so the line goes from the eye socket straight back over the ear. Imagine how a pair of sunglasses is shaped—flat across the front then straight back over the ears. Remember the ear sits behind and below the side axis lines' center point, positioned in the lower-right quadrant. With this new view, examine how the shapes of the facial features have altered from other views.

Tilted Up

This three-quarter view, when the face is looking up, shows that the tip of the nose is almost at eye level. Note the downward angle of the mouth. The nostrils are prominently seen. The shapes of the eyes and eyebrows curve downward at the sides. Yet again, examine carefully the shapes of the ears, eyes, nose, mouth, forehead and chin when the head is at this angle.

PLANES OF THE HEAD

A basic comprehension of the planes of the head will enable you to more easily and accurately draft a three-dimensional face and head. That understanding will enable you to see, for instance, how a man's very sharp nose or jaw is made up of clearly defined planes, while a child's chubby cheeks and doughy jawline have almost no noticeable planes. Being able to distinguish these subtle differences by having a good grasp of the planes of the head will help you create a good likeness for each unique subject.

Some general guidelines about the planes of the human head:

- Men's heads tend to show more clearly delineated planes than women's, and men and women more than children.
- The younger the child, the softer the planes will be. Because an infant or toddler will have less defined planes, their faces would be drafted from a number of circles and ovals.
- The more elderly your subject, the more sagging, wrinkled or puffy skin you may find, usually obscuring some of the planes of their face while accentuating others.
- The planes of overweight subjects' heads will be softened by the fat in the face.
- Facial hair on men will soften the planes of the lower face.

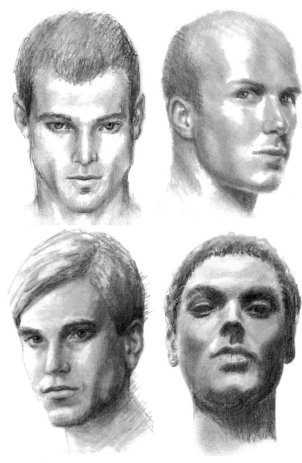

Examples
Here are some examples of the planes of the face when the head is at different angles and with different light sources.

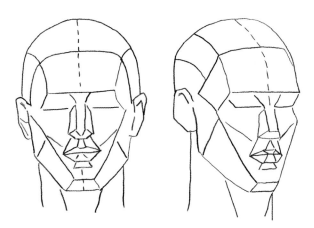

Planes Without a Light Source
Here you see the abstract planes of a male head regardless of where the light source is. No values have been incorporated.

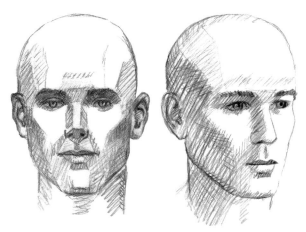

Planes With a Light Source
To translate that onto a real face, you can see that same human head shaded with more realistic values using a light source high overhead.

SQUINT FOR FACE VALUES

Although a traditional block-in does not incorporate values, if you are drawing a complex subject like a face and there is a strong light source creating strong values, try building your drawing with those values at the outset with this block-in alternative. As I've stated before, squinting is the best way to simplify a composition down to its main values.

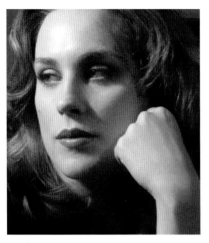

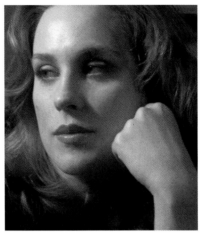

Light Source
The light source in this photograph is strong and close to the face, creating defined values across the face and hand.

Blocking In the Image
Squint and lightly hatch or crosshatch your blocks of values. Don't worry about getting the right values yet. Just get them blocked in as whole areas of value. Your finished block-in should look like this.

Build the Face
Squint again and compare the actual values of each area between the reference photo and your drawing, darkening where appropriate. Use your kneaded eraser to subtract the lightest values in the right eye and nose area, and your pencil to create details such as eyelids, eyelashes and nostrils. (See sidebar.) Continue developing until the drawing is finished to your satisfaction.

DRAW FACIAL FEATURES

Everything we see in life is composed of values. The thing to keep in mind anytime you are drawing facial features is that the values describing them change with the slightest tilt of the head and light source variation. Every feature is three-dimensional; none of them are drawn on a flat plane, such as a football shape with a circle in the middle for an eye, or a couple of C-curves for an ear. Observe the sketches that follow and study the wide variety of shapes possible. I recommend tracing each of these and then sketching them freehand.

EYES

You've probably heard it said that the eyes are the windows to the soul. If you can accurately render the expression in them, you've taken a big step toward capturing your subject's essence. Of all the features, eyes (as well as mouths) tend to show the most variety because not only does the angle of the head change their shape but they also shift with human emotion. An eye changes shape from a straight-on to a three-quarter view, but will change yet again if the person is smiling, looking down or squinting in the sunlight.

Some eyes are hooded, which means you don't see much or any of the upper eyelid crease. The upper eyelid will be drawn more as a single line than a gradation of values.

When the subject is smiling, the eyes will become smaller, so you won't see so much iris or sclera (the white of the eye), and the natural fat deposits under the eye will bunch and crease.

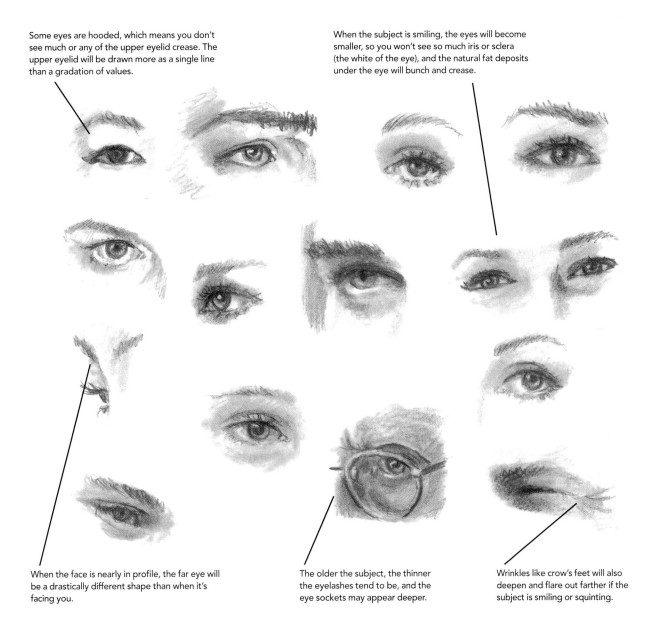

When the face is nearly in profile, the far eye will be a drastically different shape than when it's facing you.

The older the subject, the thinner the eyelashes tend to be, and the eye sockets may appear deeper.

Wrinkles like crow's feet will also deepen and flare out farther if the subject is smiling or squinting.

MOUTHS

Mouths communicate such a wide variety of emotion and movement that using values will really help you render this feature accurately. Mouths move so much they're like shape-shifters. Make a keen study of different faces in different positions. Keep in mind that most lower lips are fuller than the upper lips.

A mouth can show tension in several ways such as when it stretches to smile, pinches together in anger or is speaking.

Mouths at rest may show some teeth or none at all. There will be no tension in the mouth and the lips may be very smooth.

A shadow will usually be cast from the bottom lip onto the chin with an overhead light source, especially with very full mouths. There will be less of a shadow, if any at all, as lips stretch flatter into a smile.

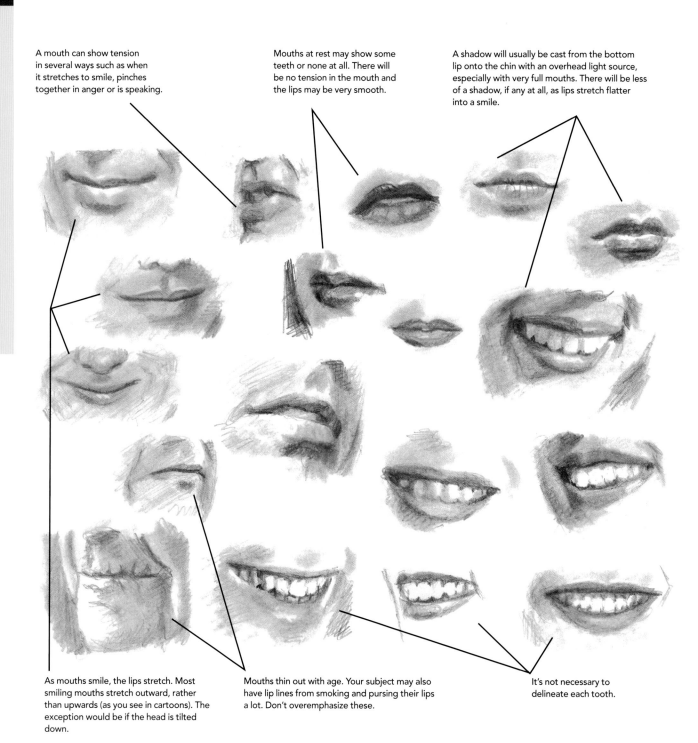

As mouths smile, the lips stretch. Most smiling mouths stretch outward, rather than upwards (as you see in cartoons). The exception would be if the head is tilted down.

Mouths thin out with age. Your subject may also have lip lines from smoking and pursing their lips a lot. Don't overemphasize these.

It's not necessary to delineate each tooth.

DEMONSTRATIONS
EYE AND MOUTH

For these brief demonstrations of an eye and mouth, you'll be using a basic frontal view. The eye will be looking straight at the viewer and the mouth will be closed.

1 ALIGN THE EYE HORIZON-TALLY
Typically, when an eye is on a level horizontal plane (the head isn't tilted to the right or left), the inner corner of the eye (with the tear duct) will be positioned a little lower than the outer corner. Of course, this can be altered for each unique eye you draw.

2 DRAFT THE PUPIL AND IRIS
In a relaxed position, the top of the iris is hidden beneath the upper eyelid. Lightly sketching the hidden lines can help with your sizing and placement.

3 FILL IN VALUES
Erase any axis and hidden lines and start to give the iris and pupil more definition. Leave a tiny spot in the pupil for the catch light. Render the slight shadow cast by the upper eyelid onto the eyeball following the line of the eyelid with tiny hatch marks and blending. The eyeball is spherical, so shade ever so slightly at the corners of the sclera.

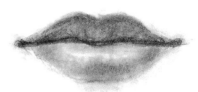

1 ALIGN THE MOUTH
Lightly draw axis lines and align the corners of the mouth with the horizontal axis line. Be aware the line between the lips is not usually a straight line and is shaped differently on different mouths. The vertical axis line can help you center the dip of the upper lip (Cupid's bow).

2 FILL IN THE UPPER LIP
Erase your axis lines. The light source is above this subject, casting a darker value across the upper lip. There's a little reflected light from the bottom lip on the upper lip, showing the convex curve of the upper lip. The dividing line between the lips will be the darkest value of the whole mouth.

3 FILL IN THE LOWER LIP
With the light overhead, the lower lip is catching more of the light than the upper lip. The highlight will be more pronounced on the lower lip, especially since this subject is wearing lipstick. Glance back and forth many times to accurately render the subtle values that communicate the particular shape of the lip.

EARS

Ears may not change with emotion or expression as eyes and mouths do, but there is some variety from person to person and the shapes of ears do change with the angle of the head. Also as subjects age, the earlobes tend to stretch and lengthen.

When drawing the ear, be aware of whether the earlobe is attached or unattached.

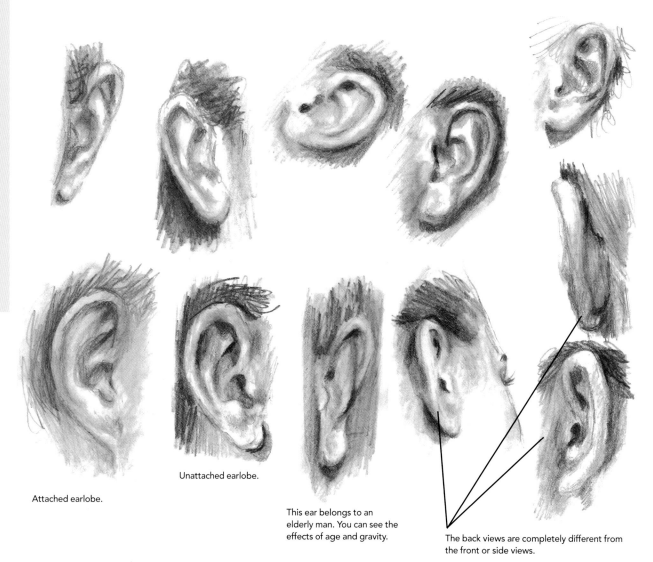

Attached earlobe.

Unattached earlobe.

This ear belongs to an elderly man. You can see the effects of age and gravity.

The back views are completely different from the front or side views.

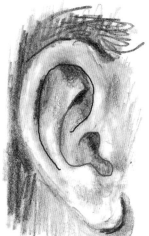

Curves of the Ear

Despite the illusion of complexity, the curves of the ear are largely made up of two lines winding around each other: the red outer line (the rim of the ear) and the blue inner line (the fold inside the outer rim).

NOSES

You'll find tremendous diversity in human noses, and the slightest inaccuracies can completely change a person's likeness. Usually noses are largely made up of values since there aren't many sharp lines such as you may find with eyes, ears and mouths. Noses can also catch interesting highlights. Master your values to render noses accurately.

Gauge how much of the nostrils is actually showing and how to render the nostrils without making the nose look too flared or pig-like.

The wider a person smiles, the more the nose will stretch outward and the nostrils will rise higher than the septum, the cartilage between the nostrils that doesn't move. This movement will appear different whether the subject is facing forward or tilted at an angle. Noticeable folds or creases may arc down from the nostrils to the corners of the mouth. It's easy to mark those lines too darkly. Be subtle.

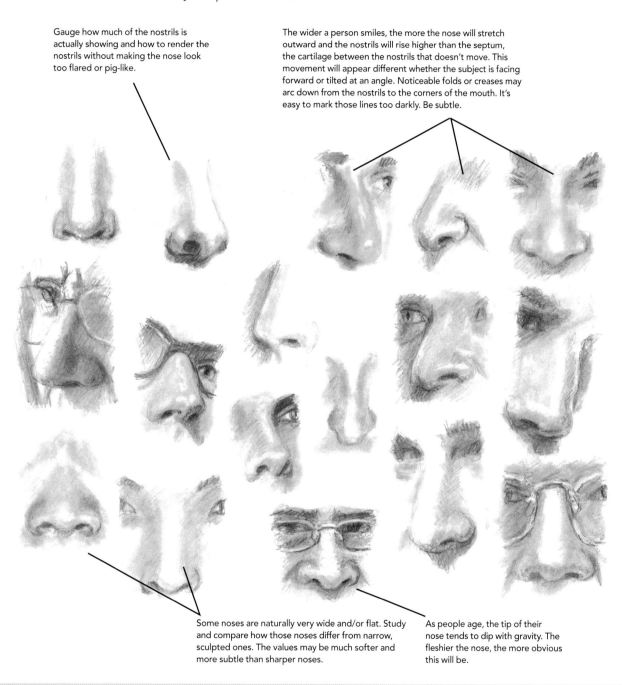

Some noses are naturally very wide and/or flat. Study and compare how those noses differ from narrow, sculpted ones. The values may be much softer and more subtle than sharper noses.

As people age, the tip of their nose tends to dip with gravity. The fleshier the nose, the more obvious this will be.

TIPS

Try drawing the same nose from multiple angles.

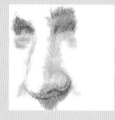
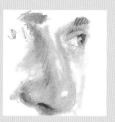

DEMONSTRATIONS
EAR AND NOSE

A profile view of an ear is a good opportunity to observe all the lines and values that comprise an ear. But a more symmetrical view of the nose is best seen from a frontal view.

1 ALIGN THE EAR AND DRAFT THE RIM

When a person is holding her head on a level horizontal plane (not facing up or down), her ear will tend to lie along a slightly slanted vertical line, with the lobe placed just in front of the start of the outer rim. Draft the outside rim of the ear.

2 DRAFT THE INNER LINES OF THE EAR

You will lose some of these lines as you develop values, but lightly sketch them to guide you as all these curves and lines have different values you'll need to match.

3 FILL IN VALUES

Erase your axis line. Much of the ear is made up of different, undulating values, so use your techniques of glancing back and forth and squinting. Try to lose your lines before fully developing your values as erasing those lines will remove some of your values. Be sure to note the correct values and sizes of the highlights.

 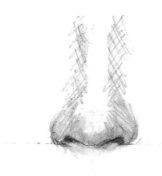 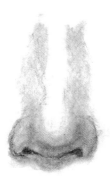

1 ALIGN THE NOSE

Use your axis lines to align the nose. Observe closely how far the septum dips below the base of each nostril. Even tiny adjustments here change the entire appearance of the nose and hence the face.

2 HATCH IN VALUES

Erase your axis lines. Because most of the nose is values, you'll be hatching those in early. Study where the values are darker or lighter, and adjust your hatch marks and pencil pressure accordingly.

3 FINISH VALUES

Continue glancing back and forth and developing those values with finer hatch marks or a tortillion. Don't forget to leave some unblended areas for highlights.

DEMONSTRATION
PORTRAIT

A portrait may be one of the most challenging drawing projects to take on but if you draw what you see, not what you think you know, then portraits can appear a little less daunting.

Your brain will try to tell you things about facial features, face shape and other elements that quite simply do not align with what you are in fact seeing in the subject. So keep asking yourself, "What am I actually seeing?" Using your hand mirror technique from the beginning is key to rendering your shapes and values accurately. But keep in mind you're going for a reasonable likeness. Otherwise you can obsess over a single drawing indefinitely. The simple elements and strong values of this photograph make it suitable for a beginner.

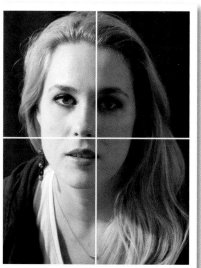

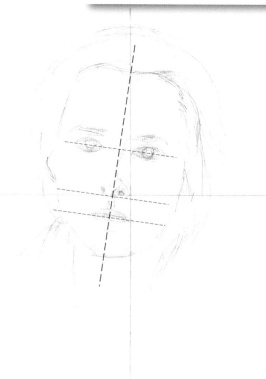

1 PREPARE YOUR PAPER
Lightly draw your axis lines with an HB pencil. (Though I recommend toned paper for portraits, this subject's fair skin tone also works well with white paper.) A reminder: If you're looking to professionally frame a drawing, be aware the picture frame and mat will cover some of the paper edge all around, so frame your drawing accordingly as you draw it.

2 BEGIN BLOCKING IN
Using the axis lines to measure from, glance back and forth and begin to draft the features. The head is tilted so take your ruler and run a slightly tilted line across the pupils. Keeping the ruler parallel with this line, drop the ruler down to the base of the nostrils, the Cupid's bow, the corners of the mouth and the earlobes to make sure all are parallel with each other. Observe which parts of the face are in which quadrant (the nose, for instance, is solidly in the top-left quadrant, not in the middle of the paper). If you're having trouble getting features placed correctly, try subdividing quadrants.

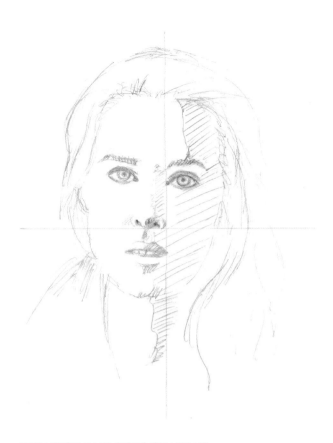

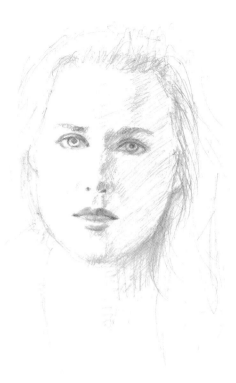

3 HATCH IN BLOCKS OF VALUE

There's a primary light source coming from the left and a faint secondary light source on the right. So the lightest planes of her face will be the left side, with her right side gently illuminated. Carefully and lightly hatch in the shadow planes including those on the upper lip. Notice how the cartilage on the tip of her nose is forming a core shadow and the left nostril is described only by the faint shadow on her cheek. Now that you're moving into shading, remember to squint at your subject frequently to accurately evaluate your values.

4 BEGIN TO DEVELOP VALUES

Erase your axis lines. Switch to a 2B. The forehead has a very faint core shadow and the darkest area of the face is around the right eye, so hatch that side of the face as well as the white of the eye.

Lightly erase the outline you drew of the lips and render the changing values of the upper lip, letting those values form the border of the lip instead of the blocked-in outline. Erase the very center of the Cupid's bow. Notice the teeth are in shadow as well and continue that shading just a little bit for the top of the bottom lip. For the bottom lip, let the paper be the highlight and shade in the underside to indicate the fullness.

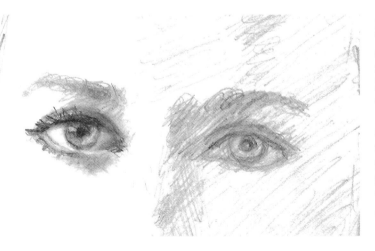

5 DEVELOP THE LEFT EYE

Blend a darker value over the shadowed side of the eye (inner corner), leaving the iris alone. With the catch light on the upper left of the iris, the opposite side will be highlighted because the shaft of light is running through the convex cornea covering the pupil.

The inner rim of the lower eyelid is slightly darker at the outer corner and lightens as it runs around the curve of the eye to the tear duct. Notice the shadow under the entire eye. For the eyebrow, render a basic tone over the whole brow, careful to go lighter at the side receiving the most light (outer corner). Then lay in darker marks to indicate the individual hairs without overworking it. Not every single hair needs to be rendered.

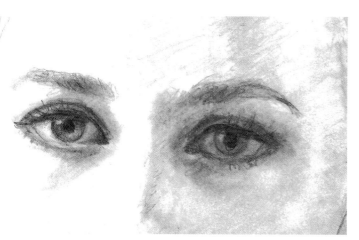

6 DEVELOP THE RIGHT EYE

As you progress to the other eye, you'll see all the values are darker and much flatter than the first eye because the right eye is in the broad cast shadow from the bridge of the nose.

Lay in darker lines for the eyelashes (but don't overemphasize them with a spidery effect) and use your value scale to compare carefully for the values of the inner rim of the lower eyelid. There's a very subtle shadow under the whole eye near the tear duct. Use the same technique for the eyebrow as described in the previous step.

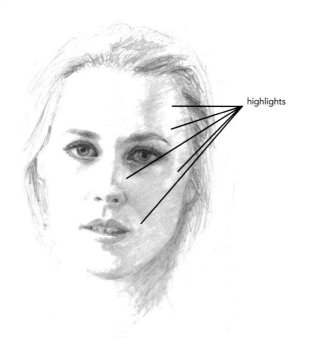

highlights

7 DEVELOP FACE VALUES

Squint at your subject and darken the face values on the right, lifting out with your kneaded eraser the lighter areas, some of which you may blend in again later once you get the hair and background values in. You may need to darken the neck to compare with the face values. You can define the shapes of the teeth with the darker value of the inside of the mouth. But don't delineate the teeth more than this.

It can be tempting to overdarken the values of the areas right around the nose and mouth because they butt up so closely with the very light values of the highlighted half of the face. Squinting and using your hand mirror will help you accurately gauge these areas.

8 DEVELOP HAIR VALUES

Work the hair loosely. Notice that the light is coming diagonally from the upper left, creating a shaft of light diagonally across the hair coming over the shoulder. The values of the hair should be darkest near the face, not only because that's where the face is blocking the light, but also because as you move away from the center of interest, you may want to keep your marks fewer and lighter to keep the focal point on the face. Squinting and glancing back and forth often are essential to getting these flowing values right. The darkest values are under the right ear and gradually lighten as the column of the neck curves toward the light.

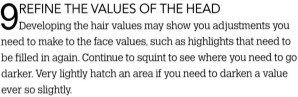

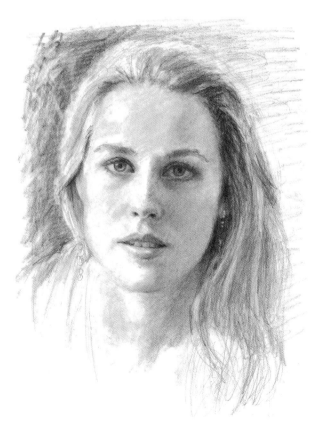

9 REFINE THE VALUES OF THE HEAD

Developing the hair values may show you adjustments you need to make to the face values, such as highlights that need to be filled in again. Continue to squint to see where you need to go darker. Very lightly hatch an area if you need to darken a value ever so slightly.

10 LAY IN THE BACKGROUND AND CONTINUE REFINING THE HEAD

Continue to work on the hair (don't overwork it), careful of that shaft of light across the bottom. With your kneaded eraser, lift out the highlight near the root of the hair at the forehead hairline and anywhere else that needs to be lightened. But blur the hairline itself.

Tone in some background so your eyes will judge the foreground values more accurately. Soften the line where the background meets the hair. You may need to lightly hatch in values for the light side of the face and neck, or go darker for the shadowed side of the face.

You can add a dark value contrast in spots around the face, like the jawbone and the hair over the left ear. These would be found lines. There's a lost line on either side of the chin along the jaw. Notice that the dark values of the inside of the left nostril lighten as the edge of the nostril curves out into the light. Lift out a few very tiny catch lights to indicate the shadowed earring.

11 REFINE THE VALUES OF THE HIGHLIGHTED HALF OF THE FACE

With a very light touch, use your tortillion to lay some graphite on the highlighted half of the face, using just the graphite that is already on your tortillion (rub it onto the darker values to pick up more, if you need). Lift out the brightest highlight above the left eyebrow.

A very light highlight falls on the tip of the highlighted half of the nose. Use your electric eraser to lift out the very tiny highlights along the bottom lip. Note the highlight on the left side of the upper left eyelid and the highlight on the shadowed brow bone.

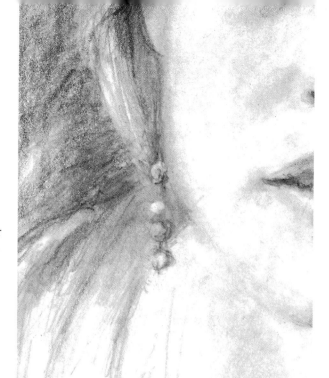

12 REFINE THE LEFT EARRING

Those few catch lights you put in in step 10 are enough for the shadowed earring. Just refine the highlighted earring a little more. That earring doesn't have to be exact and you don't want to call too much attention to it. It's not the focal point, so line variation comes into play. Use your 2B or 4B to outline the first few segments (more darkly on the shadowed side of each segment), shade in according to the values you're able to discern by glancing back and forth, and use your electric eraser to lift out a few well-placed highlights. It's fine to leave the lower sections a bit sketchy with more lost lines. You can opt to render the cast shadow of the earring onto the neck or leave it out. The necklace is too far out of the focal area to matter.

13 REFINE THE BACKGROUND

A loose, sketchy background can be interesting so use your eraser to roughen the edges. Asymmetry works for a background when you have such an intentional focal point. Have some fun with a variety of hatching marks, erasures, pencils and pencil pressures. I made the left side darker and the right side lighter to contrast with each side of the hair. Beyond that, consider it an opportunity to experiment. You can always erase mistakes and try something else. It may also be beneficial to try different textures and approaches for backgrounds on scrap pieces of paper so you don't have to worry about ruining a finished drawing.

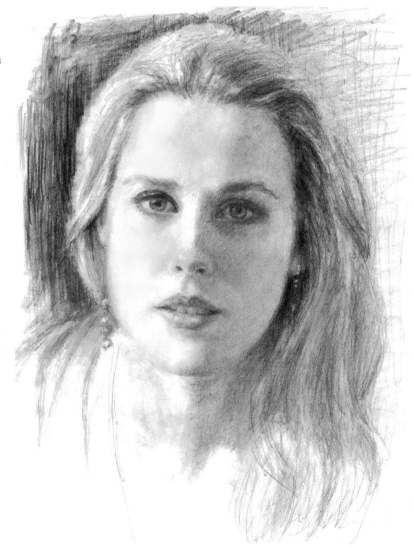

TIPS

Try turning both the reference photo and your drawing upside down to compare values and shapes; doing so accomplishes the same objective as the mirror.

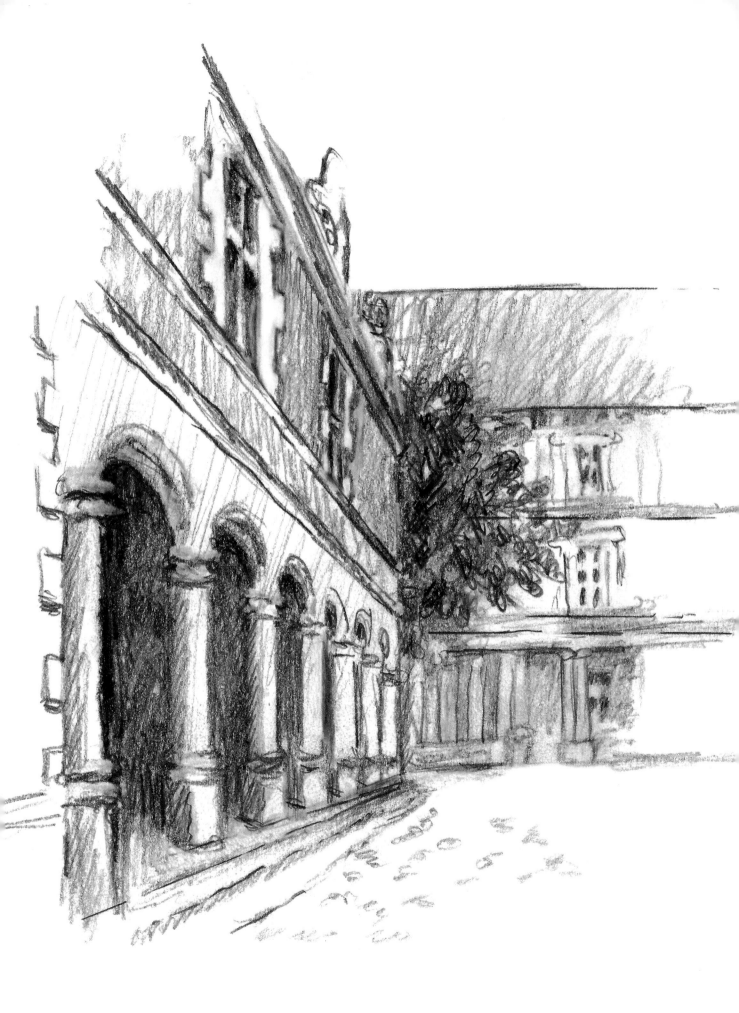

7 INCORPORATING PERSPECTIVE
IN DRAWING

Perspective is the relation of objects in space as they recede in the distance. Sounds simple, right? Not when you're an artist trying to communicate that sense of three-dimensional depth on a two-dimensional surface like a piece of paper. Everything you draw or paint will have a sense of depth, whether shallow as in a still life or dramatic as in a landscape. This chapter will provide you with the most essential perspective concepts you'll need to understand in order to give your drawings that depth.

IN THIS CHAPTER

- Observations About Perspective
- Vanishing Points, Horizon Lines and Orthogonal Lines
- Vantage Points
- One-Point Perspective
- Two-Point Perspective
- Three-Point Perspective
- Other Perspectives

Chambord Columns
Graphite on paper
11" × 8½" (28cm × 22cm)

OBSERVATIONS ABOUT PERSPECTIVE

Notice the following laws of perspective that are always in play in real life.

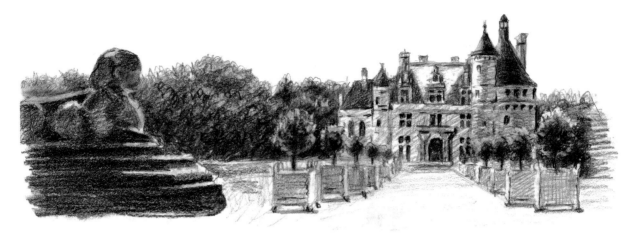

Objects Near and Far

Objects that are closer appear larger, while more distant objects appear smaller. The sphinx statue in the foreground appears almost as tall as the castle although you know of course that it's not; it only looks so tall because it is closer to you, the viewer.

Line of Sight

Line of sight is another way of describing the concept of foreshortening. To better understand, think of an invisible string straight ahead from your eye to the horizon. Everything laid along that line, like a finger that is pointing at you or a car driving toward you, will appear to have shorter dimensions than it actually has.

Objects laid across the line of sight (perpendicular to the line of sight) will appear to have longer dimensions than those laid along the line of sight because these objects are not foreshortened at all.

The body of the plane (not the wings) appears very short when viewed along the line of sight.

Now the body of the plane is revealed to be much longer when it is across the line of sight.

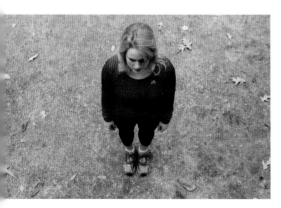

Foreshortened Vantage Point

In this photograph, if you measure with a ruler from the top of the woman's head to her heels, she will measure as a very short woman. You can also observe that her head and shoulders are enormous compared to her tiny feet, but chances are your brain wouldn't be confused. You also wouldn't think she is particularly short in this picture because you understand that the photograph was taken from a very high vantage point. Your brain automatically grasps the concept of foreshortening.

VANISHING POINTS, HORIZON LINES AND ORTHOGONAL LINES

VANISHING POINTS AND HORIZON LINES

A vanishing point happens when parallel lines appear to converge, usually on the horizon line. The horizon line is the horizontal line at a viewer's eye level. You can observe converging parallel lines on straight roads and railroad tracks.

ORTHOGONAL LINES

Straight lines that follow your line of sight to the horizon (as opposed to straight lines that go in other directions) are called orthogonal lines. Where these lines intersect, gives you your vanishing points, confirms where your horizon line is and keeps your drawing's perspective on track. Usually these lines are diagonal (although they can be horizontal or vertical depending on where your line of sight is), and they appear to radiate from your vanishing point(s).

Sometimes orthogonals are very clear, as in architectural scenes where you can follow rooflines, windowsills and street curbs back to their vanishing point. In other scenes, such as landscapes, they may be more difficult to discern.

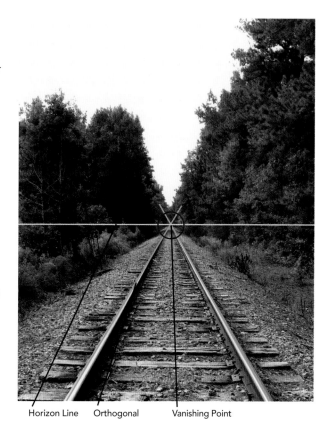

Horizon Line Orthogonal Vanishing Point

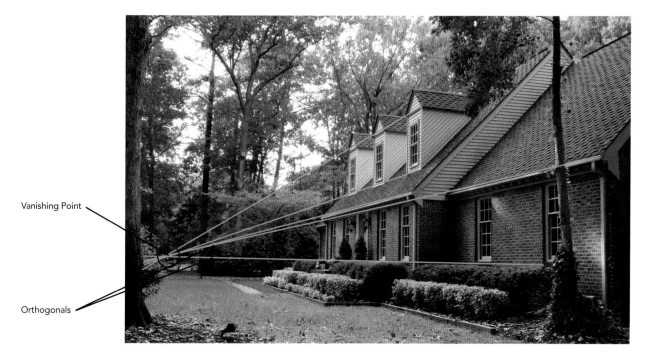

Vanishing Point

Orthogonals

VANTAGE POINTS

Vantage point refers to your eye level when viewing a scene. Remember these two facts about vantage points: The horizon line is always at your eye level and it will always intersect the vanishing point no matter your vantage point.

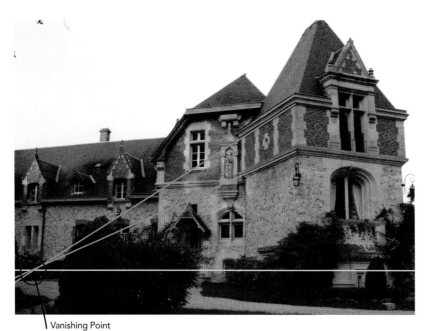

Vanishing Point

Low Vantage Point
You can have a low vantage point where you are standing below a very tall subject and looking up. This will give you a low horizon line because your eye level is low. Remember, your horizon line, eye level and vanishing points will all fall on the same plane. You can find your vanishing points by drawing your orthogonal lines carefully, and your horizon line will intersect it on a perfectly horizontal plane.

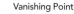
Vanishing Point

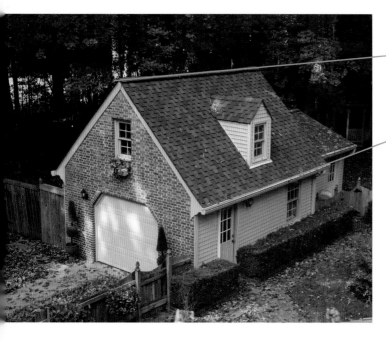

High Vantage Point
You can have a high vantage point where you are looking down on something. You will then have a high horizon line because your eye level is high, and your orthogonals will give you a high vanishing point.

ONE-POINT PERSPECTIVE

When all the orthogonal lines in a scene converge at a single vanishing point, you have one-point perspective. A hallway is a perfect example of one-point perspective.

Some of the orthogonal lines in this hallway are the crown molding at the top of the pillars and along the ceiling on the left, the shoe molding along the floor, and the top and bottom of the wainscoting moldings along the staircase and pillars.

Comparison

In this comparison, you can see how the vanishing point changes as the vantage point lowers. In the picture on the left, the viewer is standing. In the picture on the right, the viewer is sitting. But in each picture, the orthogonals still converge at the vanishing point.

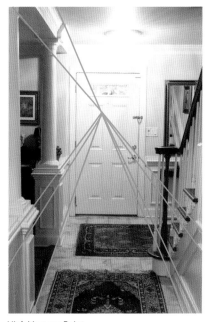

High Vantage Point

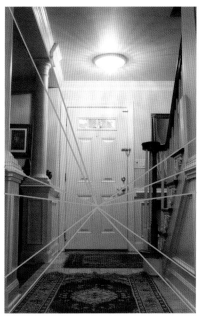

Low Vantage Point

A Single Vanishing Point

This sketch shows different vantage points from a one-point perspective and how all the separate orthogonals relate to the single vanishing point and the horizon line (remember, the eye level is the horizon line). Although this sketch encompasses different vantage points and therefore different orthogonal lines, it is still one-point perspective.

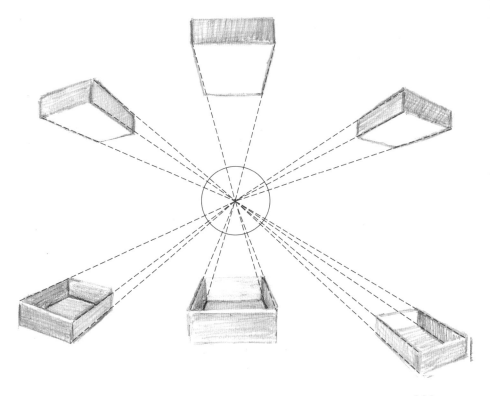

TWO-POINT PERSPECTIVE

Two-point perspective has an additional vanishing point and sometimes presents a more interesting drawing or painting than just a view from a one-point perspective. However, several factors will determine how far the left or right vanishing points are from your subject (sometimes causing them to run off your paper):

- Your viewing angle: If you are viewing your object from one corner (as in the diagram below), your vanishing points will be about equidistant from your object.
- Your vantage point: Viewing your object from up high will give your orthogonal lines a V appear-

ance, so your horizon line may be much higher or lower than your object.

- Your viewing distance: This will have the greatest effect on how far off your paper your vanishing points will be. The closer you are to your subject, the nearer your vanishing points will be, so you may need only a ruler. As you get farther from your subject, you may need to use a yardstick or meter-stick to gauge your vanishing points; you may also need to place extra pieces of paper adjacent to your drawing paper so you can sketch those orthogonals.

Vanishing Point 1 Vanishing Point 2

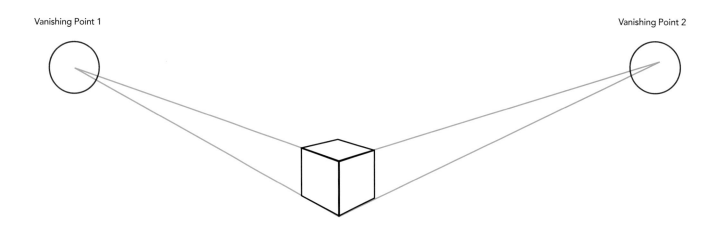

If you're working from a photograph, a great tip as you're becoming more familiar with gauging perspective is to print out a small image of your subject so you have some white space on your paper to draw your orthogonals and vanishing points, as in this diagram of the house.

TIPS

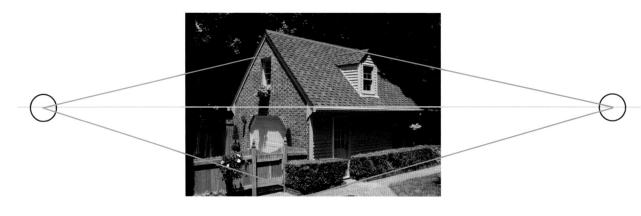

THREE-POINT PERSPECTIVE

Three-point perspective is just two-point perspective with an additional vertical vanishing point. This third vanishing point comes into play when your vantage point is extremely high or extremely low. Understanding three-point perspective will help you align the vertical lines of a structure, not just the horizontal lines, especially since with most vantage points, those vertical lines won't appear exactly vertical.

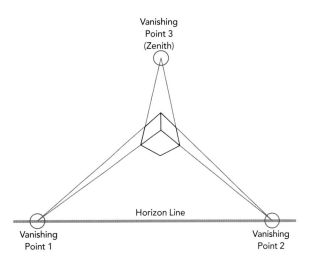

Zenith

When your vantage point is very low so your view is tilted upward, like when looking up the side of a tall building from street level, the parallel lines of the buildings don't seem to be parallel at all but look like they converge far up in the sky. This third vanishing point is called the zenith, the highest point of something.

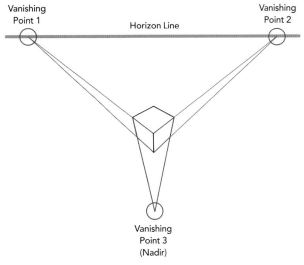

Nadir

If your vantage point is very high, as if you were looking down at a city from an airplane, it will seem like the lines of the buildings are again not parallel but converge at a third vanishing point far down in the ground. This vanishing point is called the nadir, the absolute lowest point of something.

OTHER PERSPECTIVES

ZERO-POINT AND ATMOSPHERIC PERSPECTIVE

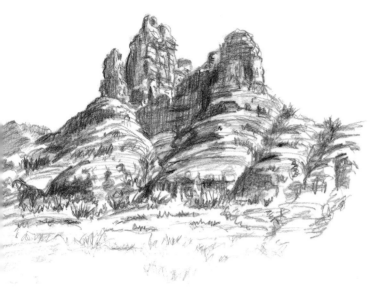

Desert Mountains
Graphite on paper
8½" × 11" (22cm × 28cm)

Sometimes a composition has no parallel or orthogonal lines and therefore no vanishing points, but perspective is still present. This is called zero-point perspective. Landscapes are very common examples of this kind of perspective. Nature rarely gives us perfect parallel lines and easily measured vanishing points. However, zero-point perspective can still have a sense of depth.

Artists can convey that depth through the use of atmospheric perspective (or aerial perspective) where dust and water vapor hanging in the atmosphere partly blur and soften our view of distant objects. Objects close to the viewer are drawn darker with defined edges. Objects farther in the distance are drawn lighter with the edges slightly blurred. The horizon may not be very defined. When working with color mediums, those objects in the distance will often be rendered with a bluish tinge.

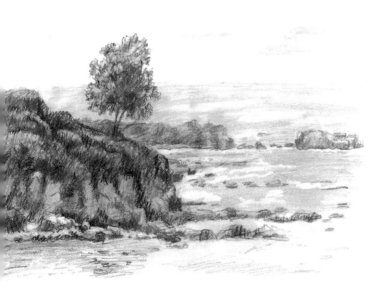

Atmospheric Perspective
The rocks and trees in the foreground are drawn sharply and darkly, while the rocks in the distance are paler and blurrier.

Laguna Beach
Charcoal on paperr
8½" × 14" (22cm × 36cm)

Clouds in Perspective
As you can see in this photograph, even clouds can follow the laws of perspective. They can also present interesting possibilities for your sketch pad and can give you practice in representing zero-point and atmospheric perspective.

DIMINISHING PERSPECTIVE OF EQUALLY SIZED OBJECTS

Many things you observe have regularly spaced components like columns, windows, fence posts, pier posts or telephone poles along a highway. When one of these is viewed in one-point perspective, it can be a little tricky to get that object's elements spaced correctly because they diminish in size and distance from each other as they recede to their vanishing point. But there's a way to get the exact spacing that will be especially helpful if you like to include architectural features in your compositions.

1 DRAW YOUR FIRST TWO FENCE POSTS
In drawing the fence shown above, begin by focusing on the first two vertical objects (the nearest two fence posts) and draw them as accurately as you can, estimating the correct difference in height from the first object to the second and their distance from one another.

2 ESTABLISH YOUR VANISHING POINT
These first two verticals establish the upper and lower orthogonals. Where they intersect is your vanishing point. The more similar in height your first two vertical lines are, the more parallel your orthogonals will be and thus the farther away your vanishing point will be.

3 DRAW YOUR HORIZON LINE
Now that you have determined the vanishing point, you can draw the horizon line, a perfectly horizontal line intersecting the vanishing point. Your T-square can help you achieve a perfectly horizontal line.

4 FIND YOUR MIDPOINT
Draw straight lines diagonally from the top-left post to the bottom-right post and from the top-right post to the bottom-left post. This X will give you a center point; mark that point with a little dot.

Other Perspectives

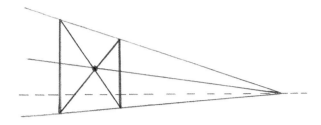

5 DRAW YOUR MIDLINE ORTHOGONAL

Line up a ruler between that center point and the vanishing point and draw a light line. This third orthogonal line between the upper and lower orthogonals gives you a midline for each subsequent fence post.

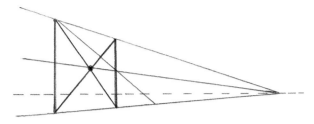

6 ORIENT YOUR THIRD FENCE POST

With a ruler, draw a line from the top of the first (left) post diagonally through the midline of the right post and continue it down to the bottom orthogonal. This point gives you the base of the next fence post.

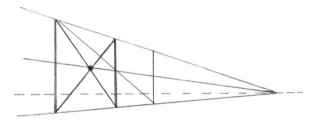

7 DRAW YOUR THIRD FENCE POST

From that point, draw the next vertical line upwards and stop at the upper orthogonal. This is the next fence post.

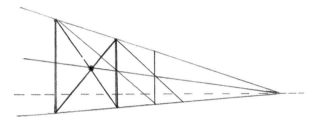

8 ORIENT YOUR FOURTH FENCE POST

With a ruler, draw a line from the top of the second fence post diagonally through the midline of the third fence post and continue that diagonal line down to the lower orthogonal. This point gives you the base of the fourth fence post.

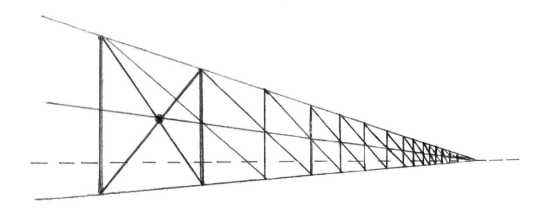

9 FINISH DRAFTING ALL FENCE POSTS TO THE HORIZON

Repeat steps 7 and 8 by starting at the top of the previous fence post and drawing a line diagonally down through the midline of the newest post to the lower orthogonal. This will give you each subsequent fence post until you have reached the vanishing point. You will see the distance between the fence posts gets smaller and smaller but always remains in proper proportion. (Don't forget to draw all these lines lightly so you can draw the actual objects—fence posts, telephone poles, pier posts and so on—without ghost images from these plotting lines.)

DRAW FIGURES RECEDING IN THE DISTANCE

Here is a step-by-step process you can use to accurately render proportion in relation to the horizon. In this case, I used a figure, but you can use this process to plot trees, animals, buildings or other subjects as long as they are similarly sized. This particular technique won't work if you are trying to apply it to differently sized objects like two adults, a child and a dog.

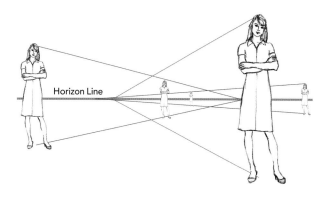

Other Perspectives

1 FIND YOUR HORIZON LINE
Select the placement for the horizon line, which is at eye level.

2 ESTABLISH THE HEIGHT OF YOUR FIRST FIGURE
Establish the height of the first figure (it can be any height so the line can be any length). Label this line AB.

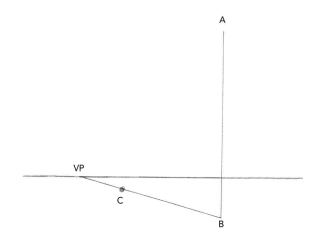

3 ESTABLISH THE BASE OF THE SECOND FIGURE
Set a point for the feet of the second figure (you can place it anywhere). This point is C.

4 FIND YOUR VANISHING POINT
Draw a line from B through C to the horizon. This lower orthogonal establishes your vanishing point.

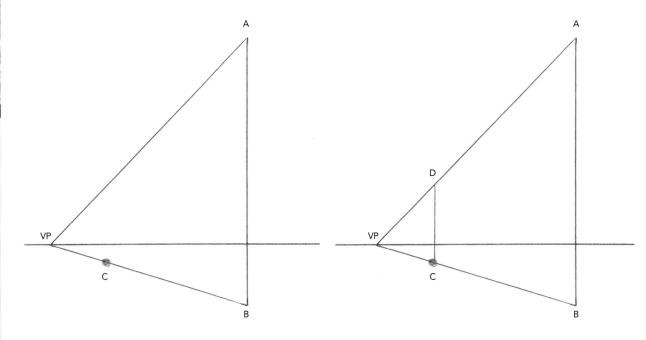

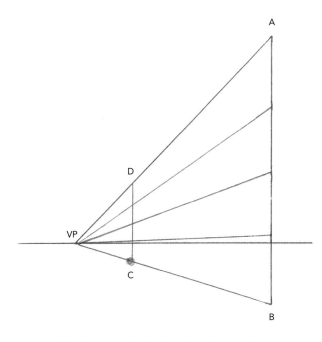

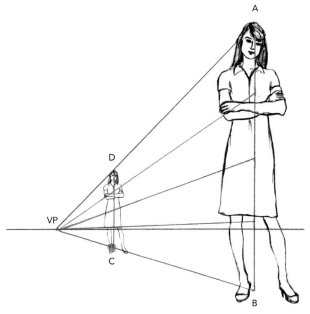

5 DRAW YOUR UPPER ORTHOGONAL
Then draw the upper orthogonal from the vanishing point back up to A, the top of the first figure.

6 DETERMINE THE HEIGHT OF THE SECOND FIGURE
Draw a vertical line up from C and stop at the upper orthogonal. Label that upper point D. The CD line, which is also perpendicular to the horizon line, will be the second figure.

7 DIVIDE THE FIGURES WITH ORTHOGONALS
Divide this triangular space into fourths to mark the chest, groin and knees of both figures. Do this by bisecting the entire triangle into two halves (giving you the groin), and then bisecting each half (giving you the chest and knees).

8 DRAFT YOUR FIGURES
Build your figures using the orthogonal lines you drew for different parts of the bodies. Block in lightly; at this point you're establishing proper perspective, not developing details on the figures.

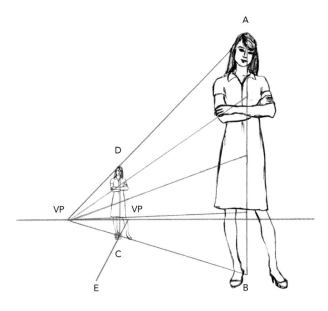

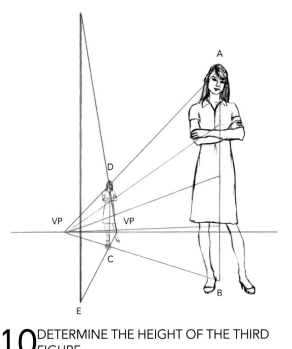

9 ESTABLISH YOUR SECOND VANISHING POINT

To draw more figures in this composition, make another point (E) to mark the base of the third figure. Draw a line from E through C to the horizon. Mark your second vanishing point.

10 DETERMINE THE HEIGHT OF THE THIRD FIGURE

Determine the height of your third figure and draw the upper orthogonal line for that figure down to the horizon line to join with the lower orthogonal you already drew (line CE).

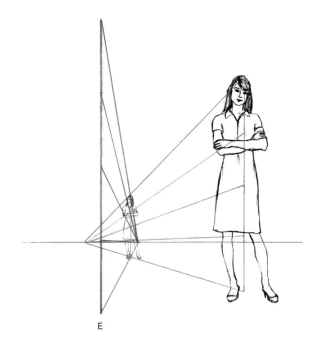

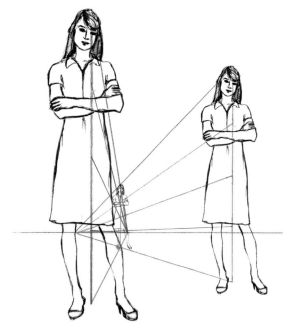

11 DIVIDE THIS NEW SPACE

Divide this new triangular space as you did before, creating orthogonal lines for the chest, groin and knees for the new figure.

12 DRAFT THE NEW FIGURE

You're just blocking in this third figure. Remember, the horizon line intersects *all* similarly sized figures on a level plane at the same point. This horizon line intersects all the figures at the knees. If your vantage point were higher, the horizon line would intersect higher, say at the hips or shoulders of all the figures.

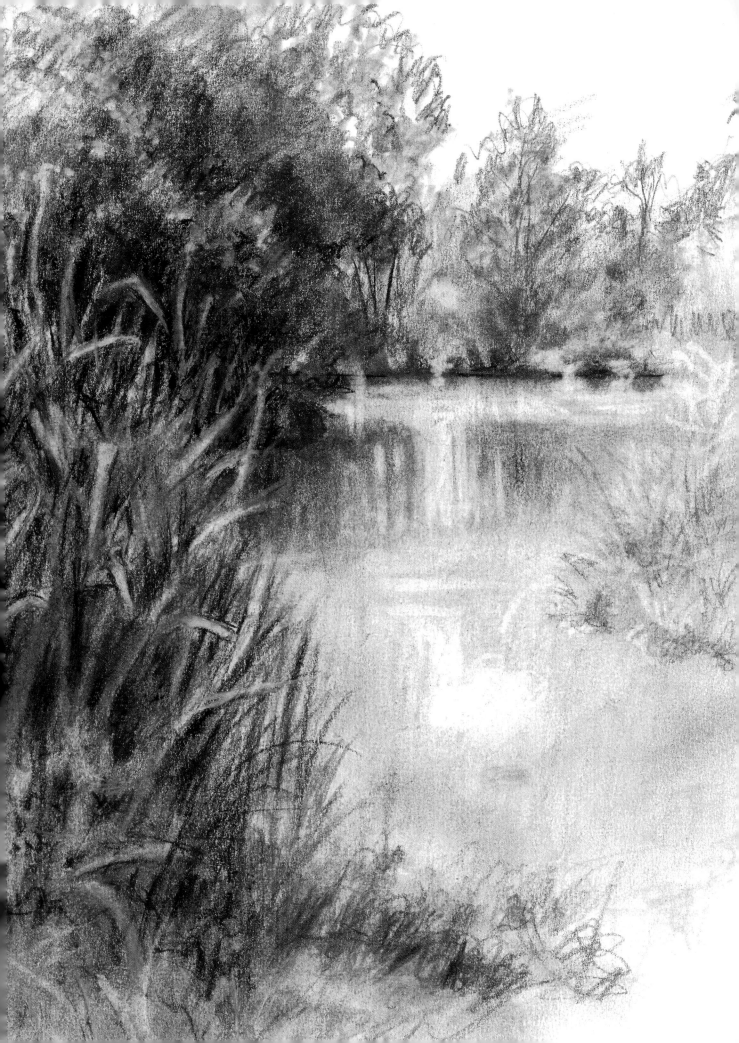

8 ELEMENTS OF COMPOSITION

Many developing artists believe all you need to create a beautiful drawing is excellent drawing skills. But even the best draftsman, without a solid understanding of good composition, can produce drawings that lack interest and don't hold the viewer's attention. While many drawing books don't venture beyond pencil techniques, I want to open your eyes to how you can combine well-honed drawing skills with elements of good composition to engage your viewer.

Although this field of study is broad, I'm going to present just a few essential compositional techniques that are easy to understand and easy to implement. Think of this chapter as a toolbox to pull from when identifying, planning or arranging your compositions. If your drawing just isn't speaking to you or seems to be missing something, revisit these theories to see how you can tweak it to make it work. These concepts can inform your perspective as an artist so you become even more aware of all the interesting possibilities for your art.

IN THIS CHAPTER

- Focal Point
- Lighting
- Rule of Thirds
- Creating Depth
- Simplify and Negative Space
- Leading Lines
- Framing and Cropping
- Incorporating the Elements

Amberley Pond
Graphite and charcoal on paper
11" × 8½" (28cm × 22cm)

FOCAL POINT

A work of art generally needs a primary center of interest, the area you want to stand out, in order to attract the viewer's eye. Your focal point doesn't have to be the largest object in your drawing. Rather, it's how you emphasize that object or area that makes it your focal point.

You can choose from several techniques to accentuate the most important object or area in a composition. One of those techniques is concentrating your most detailed work and the highest contrast between lights and darks in your focal area.

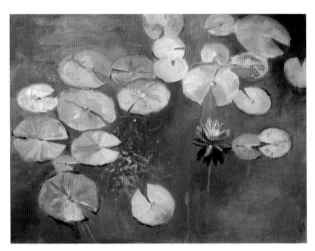

Isolated Objects

A viewer is also drawn to objects that are isolated from other elements. When looking at *Lily Pond*, your eye homes in on the flower because it is somewhat set off from the lily pads and is a dramatically different color.

Lily Pond
Oil on canvas
22" × 28" (56cm × 71cm)

Courtyard Columns
Graphite on paper
8½" × 11" (22cm × 28cm)

Different Shapes

The eye will notice a shape that is different than the surrounding shapes, for example, a horizontal shape among mostly vertical lines or a circular shape among mostly straight edges as in *Courtyard Columns*. And diagonal shapes are very dynamic and give a certain interest to a composition, as shown in *Wistful*.

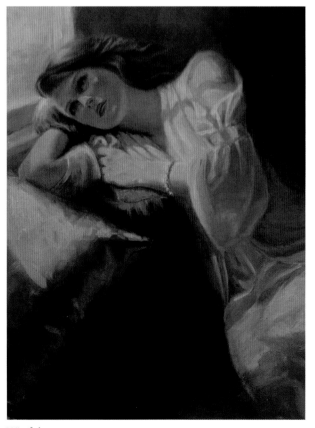

Wistful
Oil on canvas
20" × 16" (51cm × 41cm)

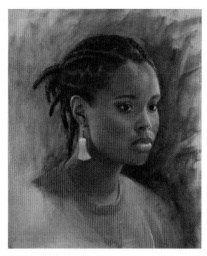

Lovely Girl
Oil on canvas
20" × 16" (51cm × 41cm)

Study in Profile
Graphite on paper
11" × 8½" (28cm × 22cm)

Chris
Oil on canvas
20" × 16" (51cm × 41cm)

Portraiture

In portraiture, the sitter's face and, in many cases, the eyes are usually the focal point and rendered with a good deal of realism. The rest may be handled more impressionistically or with less contrast. The focal point in a portrait can be broad enough to include the entire head and neck, or tight enough to be just the facial features.

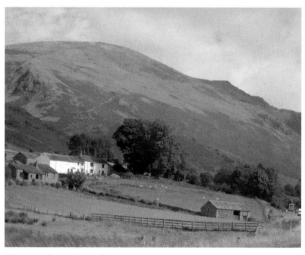

Landscape

In a landscape, the focal point may be a particular tree, a building, a boat or a flower. *Keswick Boats* doesn't have just one object as the focal point, but it's still clear what the focal area is: the two boats. They are in the foreground and are rendered with greater detail and contrast. In a still life, the center of interest could be a vase or a platter with the rest rendered with less contrast.

Keswick Boats
Charcoal on Paper
8½" × 11" (22cm × 28cm)

Secondary Focal Point

A drawing or painting may also have a secondary focal point. Although it won't have the prominence that the primary focal point has, it can be a valuable tool in directing the viewer's eye to the main center of interest. In this photograph of a mountainside farm, the white house is the main focal point with the smaller barn in the bottom right serving as the secondary focal point.

LIGHTING

Lighting can be a tremendously effective tool to draw your viewer's attention to your chosen focal point, whether in a still life, figure, landscape or portrait drawing. Bright natural light streaming in through a window on your subject can present great artistic opportunities, but unless it's northern light (in the northern hemisphere), natural light (and therefore your shadows) will constantly change with the sun's position in the sky, making it much tougher to draw from life using natural light. So it's easiest to experiment with lighting by using artificial light in the form of a clip-on or standing lamp.

Strong lighting creates strong shadows which can serve almost as another element of composition. Try turning off all the other lights in the room so there is a single shaft of light highlighting the focal point. Those strong cast shadows can link the objects in your composition and ground them so they don't look like they're floating.

The focal point is the star of the show with the light source highlighting it, leaving the rest of the elements more shadowed and subordinate. However, if the shadowed objects appear too faint, set up a softer secondary light source.

Chinese Statue
Graphite on paper
11" × 8½" (28cm × 22cm)

Highlights
This Chinese figurine is lit by a diagonal shaft of light that highlights the carved folds of her robes, providing nice contrasts. The dark background sets off the figure beautifully.

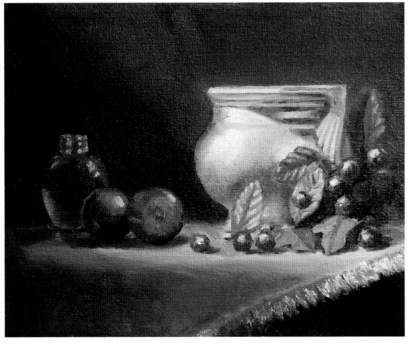

Diagonal Light
You can see how the strong diagonal light source draws your eye straight to the gold vase.

Brushed Gold Vase
Oil on canvas
8" × 10" (20cm × 25cm)

RULE OF THIRDS

Chances are that in many of the compositions you like best, the focal point is slightly off center. Very often when artists plan their compositions, they incorporate the Rule of Thirds. It states that in a composition divided into nine equal parts by two equally spaced horizontal lines and two equally spaced vertical lines, it is pleasing to the human eye when the main subject is placed on one of these lines. If the main subject is placed on an intersection of two lines, even better. You don't have to place your main compositional element exactly on one of the lines, but it should be fairly close.

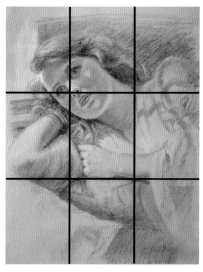

Tension and Energy
The Rule of Thirds is generally acknowledged to make a composition interesting because of the tension and energy it creates. It can be used on canvas or paper of any dimension, whether square or rectangular.

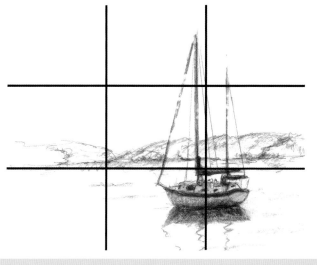

Horizon Lines
If you are painting a landscape using the Rule of Thirds, try placing the horizon line either below or above the horizontal midpoint for interest. This technique also applies to a table on which a still life is placed.

TIPS

Incorporating asymmetry in your composition can liven it up and give it interest and even drama. You can do this with the Rule of Thirds as well as the Rule of Odds, which states an image tends to be more interesting with an odd number of objects or elements, rather than an even number. Variety keeps things from being stale—the same reason you don't want your line width to always be the same or the focal point to always be centered. However, sometimes a composition just demands symmetry by having the focal point right in the middle. This works best when that focal point is meant to command the viewers' full attention, or a traditional or formal presentation is intended.

CREATING DEPTH

Overlapping your objects creates visual depth and three-dimensionality. Place some objects closer and some farther back. If you're arranging a still life, try to put the objects on different planes or draw from a higher vantage point and make sure the elements are not all equally spaced to avoid a posed or staid composition.

Be conscious of having too many objects barely touching (or "kissing") each other. When objects appear arranged in a line, it's difficult for the viewer's eye to discern the perspective of the picture (which objects are closer, which are farther away). It can give a disquieting impression of all the objects being isolated from each other. Either let most or all of the objects overlap or leave some distance between them; this will make your composition more interesting to view.

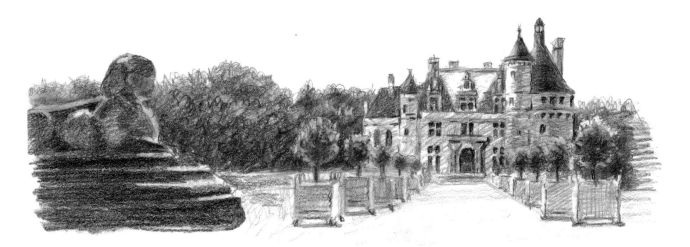

Distance
As your objects increase in size and distance from each other, your mastery of perspective will play a crucial role in making a successful drawing or painting.

Chenonceau Entrance
Graphite and charcoal on paper
8½" × 14" (22cm × 36cm)

Foreground, Middle Ground and Background
Another way to communicate depth in a drawing or painting is to include a foreground, middle ground and background.

To make a landscape drawing or painting more interesting, try to include something of interest in the foreground like rocks, fences, paths, hedges, a stream, trees or even shadows.

Brandywine River
Oil on canvas
20" × 16" (51cm × 41cm)

SIMPLIFY AND NEGATIVE SPACE

A difficult compositional technique to master is to simplify your composi-
tions by limiting the clutter so the viewer can more easily focus on the
primary objects. This is difficult because it requires restraint and editing.

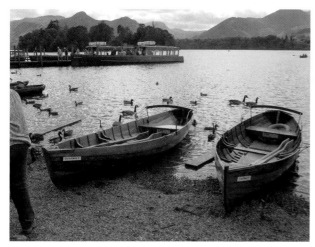

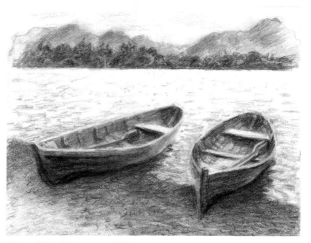

Original Photograph
At first glance, the focal point is the boats, but the viewer is
quickly distracted by the person walking out of the frame, the
crowd of ducks and geese, and the dock in the distance jutting
halfway into the composition, blocking the lovely view of the
trees and mountains in the distance.

Simplified Composition
With the person, the birds and the dock removed as well as a
few extraneous details on the boats, the composition has been
calmed, and the viewer is able to focus on the boats more easily
and to move through the landscape more leisurely. The diagonal
lines in the foreground don't have as much competition for the
viewer's attention.

Negative Space
Use negative space to your advantage when identifying or
arranging compelling compositions. Remember, negative space
is the area of your drawing not taken up by your main subject
in the focal point or other area of interest. It is a critical part of
many compositions. Most people focus on the positive space,
especially the focal point, but artists can lure the viewer into
their drawing or painting by using negative space intentionally.
When you unclutter your composition, you allow for more nega-
tive space, thus providing a resting place for the eyes so your
viewer can really linger on the focal point.

Daffodils
Oil on canvas
7" × 5" (18cm × 13cm)

LEADING LINES

Lines such as a river, fence or walkway can be very effective compositional aids because they guide your viewer's eye through the different elements of your drawing and around the whole work. These types of lines are called *leading lines*. These lines can take your eye straight to the focal point of a drawing or just guide your eye through the whole composition.

They can be contoured, vertical, horizontal or diagonal. Many photographers and artists believe leading lines can elicit certain emotions from their viewer. Horizontal lines are frequently used when an artist wants to emphasize solidity and stability, and diagonal lines tend to provide a composition with vibrant movement. Contoured or curved lines may reflect grace, beauty and serenity; vertical lines often communicate strength, dignity and authority.

S-Shaped Lines
The graceful S-shape can be created by various elements such as rivers, pathways and winding country roads, and can draw the eye to the main center of interest.

Diagonal Lines
Diagonal lines infuse a composition with dynamic action by creating interesting shapes and dividing the picture into uneven parts, avoiding a contained or predictable composition. Try to avoid running a single dominant line too precisely from corner to corner.

Radiating Lines
Radiating lines bring the eye to the main center of interest and are typical features of roads, fences, rivers, pathways, sidewalks, fallen trees, shadows or even clouds. Radiating lines are featured primarily in landscapes but can be formed by any arrangement of objects that lead the eye to the focal point.

L-Shaped Lines

The L-shaped leading line has strong vertical and horizontal lines crisscrossing the picture. The vertical lines can be on either side of the composition. You can also have a main center of interest within the angle.

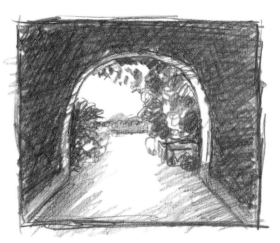

O-Shaped (Tunnel) Lines

An O-shape can be created by any combination of elements to form a tunnel such as trees, a window or a doorway. This works best when the elements seen within the O are not symmetrical.

Triangular Lines

When you place areas of interest on either side of the paper with another feature between them (either above or below) such as a mountain, architectural feature or even a cloud formation, you produce a triangular shape that leads the eye around that triangular line. It's important to note that a triangle can be formed by any three objects.

TIPS

Sometimes an O-shaped leading line is not precisely circular but achieves the same effect, such as an ivy-covered arbor or a window.

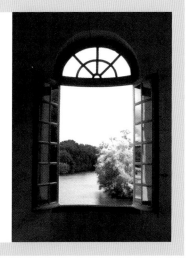

FRAMING AND CROPPING

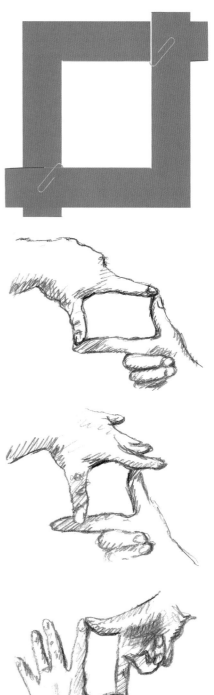

As you become a more experienced artist, you'll learn how to hone a raw composition down to a focused arrangement of elements that has focal points, drama, interest and/or emotion. A strong focus is needed especially when viewing a broad landscape; for instance, in a scene a waterfall alone may present the most eye-catching composition without the surrounding trees and land. Framing and/or cropping can help you determine how best to fill the frame with your subject (e.g., make your focal point larger or smaller, decide how many other elements to include).

To frame or crop a large composition you can use a viewfinder, draw thumbnails or take pictures of various arrangements of the elements. Any of these approaches allows you to experiment with different arrangements until you hit on the right combination. It takes time but it's all in a day's work for an artist. The artist who ignores this important prelude to drawing or painting risks wasting a lot of time and resources on a composition that's dead in the water. I've spent an hour or more setting up some compositions to get the right one before ever picking up a pencil or paintbrush because no matter how good an artist you become, if the composition doesn't work or falls flat, you've wasted your time.

VIEWFINDER

Imagine you're driving and you see a charming scene that speaks to you. You may determine the whole scene doesn't need to be drawn, but something about it strikes you. A viewfinder can help you focus the vista.

By adjusting your paper clips on your viewfinder you can change the dimensions of your tool, thereby experimenting with different dimensions for your drawing or painting. But if you don't have a viewfinder, you can use your hands to frame a scene.

USING A VIEWFINDER

A viewfinder is more useful for a live scene than for a photograph although it can be used for both. However, unlike a series of thumbnails, a viewfinder won't give you a record of each compositional possibility to allow you to compare.

Option 1
Cropping the photograph in this vertical format puts the focal point (the farmhouse) on the upper Rule of Thirds and divides the composition into pleasing layers (the sunlit farmhouse, the shaded bank and the lake).

Option 2
This smaller, square format puts the farmhouse front and nearly center, simplifying the picture by removing distractions such as the more distant trees and the water and ducks, while still leaving some greenery to ground the focal point.

Option 3
This landscape format incorporates the most elements of the three options. The farmhouse is placed on the Rule of Thirds and the long shadow along the bank guides the eye horizontally through the composition, echoing the rolling hills of the farming landscape.

Drawing Thumbnails
Drawing thumbnails by blocking in your value masses trains your eye and muscle memory for quick sketching while at the same time training your brain to see and identify elements of a composition quickly. Drawing thumbnails allows you to begin manipulating a composition right away, leaving out a tree or some ducks, shortening or lightening the bank or enlarging the farmhouse, to see what appeals to you.

INCORPORATING THE ELEMENTS

Let's put these principles into practice with some examples in the still-life genre. It's easy to throw some objects together haphazardly in a composition. But to arrange them artfully to portray movement, thereby giving everyday items significance and interest, is another thing altogether. Here's an example of a rather uninteresting still-life composition (directly below).

What makes this uninteresting?

- Too many objects roughly the same size are crowded together, so the focal point isn't obvious
- The grouping is too small for the scale of the whole composition (too much empty space all around)
- The satin fabric is too shiny over too large an area, thus competing for attention
- The lighting is diffuse, so everything is evenly lit with no interesting shadows
- Everything is too symmetrical; the grouping is right in the middle
- Some objects are totally overlapping or barely touching

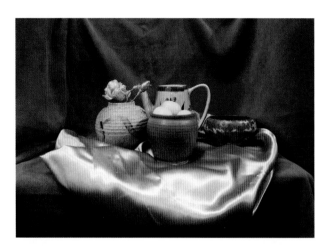

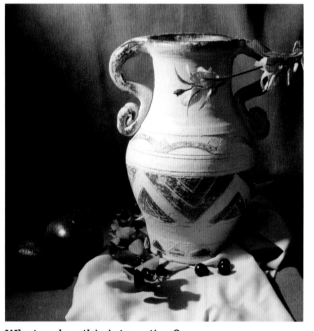

What makes this interesting?

Just a few elements keep this composition uncluttered so the focal point, the vase, is clear; it is slightly off center, which is more interesting than dead center. The oriental rug provides texture, and its diagonal lines echo the diagonal line created by the flowers, vase and pomegranates. Strong lighting provides interesting shadows.

What makes this interesting?

The dramatic light from the upper left casts a strong diagonal shadow across the background, leading your eye to the focal point. The focal point is where the light illuminates the jug's pattern and texture on the left side, which contrasts with the solid values of everything else in the arrangement.

The smaller fruits beside the jug are thrown into shadow with just a few glints reflecting off them. The shadow of the green vine curves around the jug, and the orange flower creates a slightly diagonal line that keeps your eye moving through the picture.

LIGHTING

Different Lighting
These two identical compositions are lit differently. In the first option, the background is flatter, and in the second option, the light source has been moved so it casts a diagonal shadow leading the eye toward the focal point. You also get a more distinct catch light on the bowl.

Crop for Better Lighting
Once you choose your preferred lighting, you may decide to experiment with different cropping. That diagonal shadow across the background keeps your eye from lingering in the upper-left quadrant too long, coaxing it back to the focal point where all the movement (texture, pattern, the play of light and dark) is happening.

CROPPING

Close Cropping
Cropping is unique among compositional techniques because it opens your eyes to all the possibilities in a single broad composition. This composition has vibrant colors that translate well to high-contrast values when changed to grayscale.

Those colors and an interesting angle (tilted just a bit to the side) combine with close cropping to give this composition a dynamic immediacy that catches the eye.

FINAL THOUGHTS

I have structured this book not only to teach you many skills, concepts and techniques, but also to show you that if you have the desire to draw, you can! Learning to draw is like learning any skill: It's not magic and it's not limited to those who are born with natural reserves of talent. If you diligently practice the techniques I've taught you here, you will see your ability dramatically improve. Even though there's time and frustration involved in practicing any skill set, building on the solid foundation you've gained through this book will simplify your journey significantly and teach you good drawing habits from the start that will enable you to see like an artist.

Let me sum up my most important tips:

- Always refer back to my Top Drawing Secrets in Chapter 1. Write them out and post them in your drawing area. Using these consistently as you draw will help you achieve your highest potential as an artist. From start to finish in your drawing sessions, use the hand mirror technique or stand back to evaluate your work. (You can also turn both your reference image and drawing upside down to compare them.) Glance back and forth frequently between your reference image and your drawing.
- Don't rush through the block-in stage; it is the foundation of your whole drawing.
- Start big and light, then go small and dark.
- Never forget your elements of lighting when shading your work. The light source is key to gauging these.
- Squint or use your value scale to see and render accurate values.
- Practice, practice, practice gauging relative proportions.

Lastly, I want to encourage you to continue your study of art, whether you stick with graphite and charcoal or move on to watercolor, oils, pastels, acrylics or other color media. Be a sponge and expose yourself to many different styles and genres of art to inspire you and give you direction. Find good, solid instruction in the areas that interest you most, and keep learning from great artists!

Most of all, have fun!

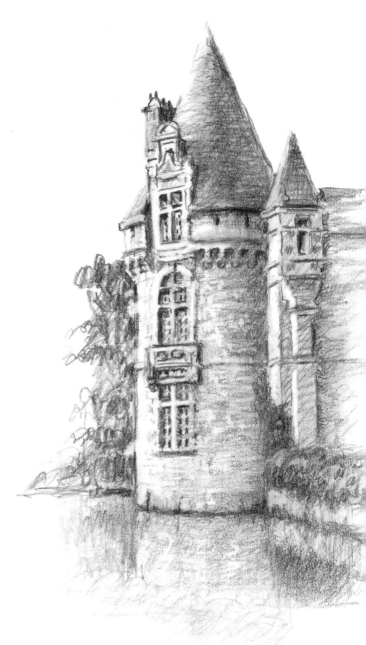

Chateau Tower
Graphite on paper
11" × 8½" (28cm × 22cm)

INDEX

RESOURCES

Strathmore/Bristol (both offered at this website)
strathmoreartist.com
paper (drawing/sketch, toned, pastel, newsprint)

Derwent
pencils.co.uk
erasers, pencils, charcoal, sandpaper, tortillions

generalpencil.com
erasers, pencils, charcoal, sandpaper, tortillions

Dritz
dritz.com
sewing gauge

Alvin
alvinco.com
drawing boards, T-squares

Drawing Secrets Revealed Basics. Copyright © 2014 by Sarah Parks. Manufactured in China. All rights reserved. No part of this book may be reproduced in any form or by any electronic or mechanical means including information storage and retrieval systems without permission in writing from the publisher, except by a reviewer who may quote brief passages in a review. Published by North Light Books,an imprint of F+W, A Content and eCommerce Company, 10151 Carver Road, Suite 200, Blue Ash, Ohio, 45242. (800) 289-0963. First Edition.

fw
a content + ecommerce company

Other fine North Light Books are available from your favorite bookstore, art supply store or online supplier. Visit our website at fwmedia.com.

18 17 16 15 14 5 4 3 2 1

DISTRIBUTED IN CANADA BY FRASER DIRECT
100 Armstrong Avenue
Georgetown, ON, Canada L7G 5S4
Tel: (905) 877-4411

DISTRIBUTED IN THE U.K. AND EUROPE
BY F&W MEDIA INTERNATIONAL LTD
Brunel House, Forde Close, Newton Abbot, TQ12 4PU, UK
Tel: (+44) 1626 323200, Fax: (+44) 1626 323319
Email: enquiries@fwmedia.com

DISTRIBUTED IN AUSTRALIA BY CAPRICORN LINK
P.O. Box 704, S. Windsor NSW, 2756 Australia
Tel: (02) 4560-1600; Fax: (02) 4577 5288
Email: books@capricornlink.com.au

ISBN 13: 978-1-4403-3440-5

Edited by Brittany VanSnepson
Cover designed by Wendy Dunning
Interior designed by Joan Moyers
Production coordinated by Mark Griffin

METRIC CONVERSION CHART

To convert	to	multiply by
Inches	Centimeters	2.54
Centimeters	Inches	0.4
Feet	Centimeters	30.5
Centimeters	Feet	0.03
Yards	Meters	0.9
Meters	Yards	1.1

ABOUT THE AUTHOR

As an artist, Sarah has always aimed to blend Impressionism with Classical Realism, especially when drawing and painting the human form, which is her favorite subject. Sarah feels she was born to be an artist, growing up in an artistic family where watercolor, ceramics and oil painting all cropped up in various branches. Earning her degrees of Art History and Studio Art from Old Dominion University in Norfolk, Virginia, was but an introduction to the art world.

As she continued to delve into painting, Sarah has observed how important solid drawing skills are to creating an excellent painting. It's this opinion that motivated her to create her online drawing course, "Drawing Secrets Revealed." And while education and teaching has become a real joy for Sarah, she continues her painting journey as she remains so inspired by so many of her fellow artists.

She has been a member for some years of Oil Painters of America, Portrait Society of America and the American Society of Portrait Artists and has had many terrific opportunities to participate in contests and exhibitions both group and solo. She feels blessed to devote so much of her life to her heart's desire and is excited to see what unfolds in the future!

ACKNOWLEDGMENTS

Thanks to my great editor, Brittany VanSnepson, who has fielded my endless questions with patience and humor. Writing a book is a huge endeavor and she made it seem a little less scary and a little more doable. Thanks to my family: my husband, Chris, who has always been my biggest cheerleader and celebrated every win, no matter how small; and my daughter, Nicole, who has developed "Drawing Secrets Revealed" with me from its inception and who has helped me shape it into a course I can be proud to teach. I have received nothing but support and encouragement throughout this entire process. Thanks to North Light Books for giving me this wonderful opportunity to do what I love: combine my passion for art with my passion to teach and help developing artists discover the joys and triumphs to be found in creating art.

DEDICATION

I'd like to dedicate this book to all those people out there who never believed they had the talent or skill to draw or paint and who didn't have anyone to tell them otherwise. I wrote this book for you. I have seen time and again hopeful new artists who have dipped a tremulous toe in the water and learned that not only will they not drown, but they can learn to swim with the big fish. The art world at its best is a community, and the best artists are the ones who can see beauty even in the roughest attempts by those who are at least trying. If you wish you could draw and wonder if you could learn, this book is my response: "Yes, you can."